D1483060

NOT ADDED BY
UNIVERSITY OF MICHIGAN LIBRARY

The last monk of the Strofades

The last monk of the Strofades

Memories from an unknown Greek Island

Robert A. McCabe
Katerina Lymperopoulou

ABBEVILLE PRESS PUBLISHERS
NEW YORK LONDON

For Father Gregory Kladis
The Last Monk of the Strofades
1937–2017

"If it falls down now, it's a lost cause. These things don't get built again. No one can build something like that now."

Contents

TEXTS

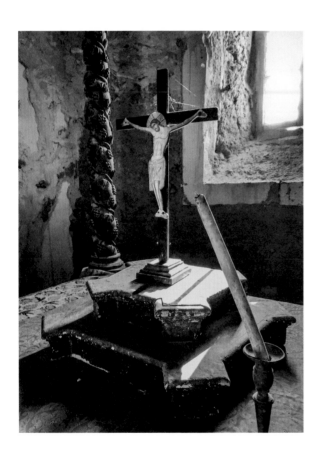

Preface

In one of the most remote corners of the Greek seas lies the tiny island of Stamfani, part of the two-islet group called the Strofades. This one and a half square kilometer island, 27 miles south of Zakynthos, is unknown to most Greeks, yet it is home to a unique, monumental fortified church within a monastic complex that has its origins in the 13th century.

The Monastery suffered severe damage in the earthquake of 1997 and today is abandoned. Its last monk died in 2017 after 38 years of devoted, virtually singlehanded service. Now only a caretaker watches over its crippled hulk. This book is the fruit of a collaboration between more than a dozen individuals interested in the island and its monastery. Its goal is to bring Stamfani to life again for the reader and, at the same time, make a case for rescuing its extraordinary monuments before they collapse into piles of rubble.

Every facet of this book reflects the devotion, resourcefulness, and thoroughness of Katerina Lymperopoulou. She delved deeply into the history of this remarkable place and organized our exceptional multidisciplinary band of contributors, to whom we are deeply grateful for their participation. You will find out more about them on the next page.

Your tour of Stamfani will be guided by Father Gregory, the last monk of the Strofades, along with the courageous boatman who used to bring him supplies; the last keeper of the old lighthouse; and other members of the Strofades family. I believe you will be amazed at what you see and hear.

Robert A. McCabe
Athens 2018

Photo opposite: Detail of the altar of the Tower church by Jenifer Neils, 2018.

Contributors

Dimitris Arvanitakis
Director of the Publishing Department of the Benaki Museum

Dr. Stamatios T. Chondrogiannis
Archaeologist, Hellenic Ministry of Culture & Sports

His Eminence Chryssostomos, Metropolitan Bishop of Dodona

Liza Evert
whose helicopter view of the Monastery before the earthquake is unique

Labis Kalofonos
The boatman who supplied the Monastery

Dr. Panagiotis Karkanas
Geoarchaeologist and Director of the Malcolm H. Wiener Laboratory
for Archaeological Science at the American School of Classical Studies
at Athens

Father Gregory Kladis
The last monk, who passed away July 2017

Archimandrite Dionysios Liveris
Abbot of the Holy Monastery of Strofades & St. Dionysios,
now headquartered in Zakynthos

Stavros Mamaloukos
Architect, MA in Conservation Studies; Associate Professor,
Department of Architecture, University of Patras

Christina Merkouri
Director of the Ephorate of Antiquities of west Attica, f. Director of the
Ephorate of Antiquities of Zakynthos

Dionysios N. Mousmoutis
Director of *History Magazine*

Dionysios Moussouras
Philologist and expert on the Monastery's archives and manuscripts
and author of the philological and paleographic study *The Monastery
of Strofades and of St. George of Krimnoi, Zakynthos*, which deals with the
manuscripts and the archival material housed at the monastery

Laurent Sourbes
Coordinator of the National Maritime Park of Zakynthos

Dimitri Stithos
The last keeper of the Strofades lighthouse

Dionysios Zivas
Professor Emeritus, School of Architecture, National Technical
University of Athens

Kostas Kefallinos, a.k.a. "the Moscovite" and Dionysios S. Tsilimigras
brought us together with the late Father Gregory, the keystone of this
volume

prima) linge a sole phusty: pane q arrido et aqua
suam substenenr gaudenr: ut altissimo immaculata
glob; suam reddet possit suam.

Strophades amb mil unu.

V Emo nunc ad Sapientia cora Modonense Ciuitate
que parua et infructuosa apparet: q dicta est Sa
pientia ut nauis transeundo sapiet? a scopulis ubi
occultis caueat: ut q ibi mulier grea cu babieng
suorra Incantationibz resoluebat: Cuius in medio

The Strophades

by Cristoforo Buondelmonti (1420)[1]

It only remains for me, father Giordano, to describe to you some venerable rocks in the Ionian sea, which were much cursed of old, known as Plotai, being one mile in circumference. They used to be called Echinades, from the sea urchins (in Greek *echinoi*) in the nearby River Acheloos. Later they were called the Strophades from the Greek *strophe*, Latin *reversio* ("turn" or "return").

On these islands there is a community of monks who lead a harsh life, existing only on fish and water. And since they were once all captured and sold by the pirates, the modern inhabitants, in order to contemplate the way of the Lord safely, built a tower where they lead a hermit's life and united in a group of more than fifty people of every origin they are invigorated.

This island, together with a smaller one nearby, in the time of Phineus, king of Arcadia, was inhabited by pirates; it is clear that they knew that Phineus, persuaded by their stepmother, Arpalica, had blinded his children; to avenge this crime they chased him all the way to Arcadia and led him into misery. They were driven off by Cetus and Calais, the brothers of Arpalica; they freed Phineus from the pirates and chased them to these islands. Therefore these young men were called Strophades, that is to say they changed the return into islands.

When Aeneas, fleeing Troy for Italy, stopped here, and was eating with his companions, the Harpies, sent from Arcadia to live on these islands, either stole their food with their talons or they polluted them with their filthy touch. When the Harpies were sent away by the sword, Celaeno, the greatest of them, spoke as follows

To Italy you shall go and freely enter her harbours; but you shall not gird with walls your promised city until dread hunger and the wrong of violence towards us force you to gnaw with your teeth and devour your very tables.

<div align="right">VIRGIL</div>

They are called Harpies from their voracity, since here a large group of pirates attacked all the people who came here with greed and plundering.

Saved from the waves, I am received first by the shores of the Strophades—
Strophades the Greek name they bear—islands set in the great Ionian sea,
where dwell dread Celaeno and the other Harpies, since Phineus' house was
closed on them, and in fear they left their former tables. No monster more
baneful than these, no fiercer plague or wrath of the gods ever rose from the
Stygian waves. Maiden faces have these birds, foulest filth they drop, clawed
hands are theirs, and faces ever gaunt with hunger.

<div align="right">

VIRGIL

</div>

These islands are now transformed from evil to good and while in the
past sailors kept them at a distance, they now happily approach them
with devoted prayers. On these islands there is a tower with a church
and at the canonical hours the monks meet inside it, and the Hegou-
menos, that is, the abbot, reads the lives of the saints in front of everyone.
Now what type of life they conduct, it is up to you to assess, father, as
it is certainly considered very harsh since they have a limited space of
one mile and are eight hundred stadia away from the mainland. Here
meat is not eaten and they are happy to sustain life on fish, which is
often sun-dried, and dry bread and water so that everybody may give
back his life to the Highest unstained.

1 Christoforo Buondelmonti, a Florence born priest, traveled extensively in the Aegean
and Ionian seas in the early part of the 15th century. In 1420 he issued an extraordi-
nary manuscript, the *Liber Insularum Archipelagi,* that contained some 80 maps and
descriptions of Greek islands. Only 60 copies of the manuscript survive today. But his
work was the basis for the first printed sea atlas, produced by Bartolomeo Dalli Sonetti
in 1485, as well as many later *isolarios,* or island books. This is his description of the
Strofades and his map reproduced here is the earliest surviving map of these islets.
The manuscript was written in medieval Latin. This English translation is by the Italian
scholar Benedetta Bessi. Buondelmonti's map of Constantinople in the *Liber* is the only
surviving depiction of the city prior to the Ottoman invasion. (R.A.Mc.)

The Strofades Monastery: History & Outlook

Christina Merkouri

The islets of Stamfani and Arpia have been known since antiquity for their strategic location and the benefits stemming from their rich water resources and distinct flora and fauna. The Ancient Greeks used to call them *Floating* (*"Plotès"*), as their flat surface gave the impression they were floating on water.

In the myth of Jason and the Argonauts, the Boreads—Zetes and Calaïs, winged sons of Boreas, king of Winds, and Oreithyia—pursue the tempestuous Harpies (*Arpyies*) to the west of the Peloponnese and to the south of Zakynthos, where one of the creatures, Aello, seeks refuge on *Plotès*. The Boreads, unable to locate her, turn back and— according to one version—rejoin the Argonauts; alternatively, they turn towards the temple of Zeus on Mount Ainos, Cephalonia, to ask for his help. It is this turning that has given the Floating islands their current name: *Strofades*, the islands of (Re)Turning.

At the northeast edge of Stamfani, the largest of the two islets, near a steep and rocky coast, stands the impressive, fortified complex of the Strofades Monastery. And on Arpia, the smaller islet to the north, separated from Stamfani by a dangerously shallow sea expanse, sits the temple of St. Onuphrius. In his travel impressions, dated from 1384, Simon Sigoli suggests that the two islets became separated after an enormous (and miraculous) earthquake which allowed the Venetian ship carrying the precious relics of St. Mark the Evangelist from Alexandria to Venice, to reach the Most Serene Republic.

The Strofades Monastery was a strategically placed observatory: built mid-sea as a patriarchal "stavropegic" monastery, on the naval routes connecting the Adriatic and Ionian seas to the southern Peloponnese and the south-eastern Mediterranean (especially the Holy Land). It also served to supply travelers with provisions.

It contributed to preserving the spirituality of Orthodox monasticism and provided a peaceful resting place for the soul. The numerous *metochia* (ecclesiastical embassy churches) connected to the Monastery (on Zakynthos, Cephalonia, and Elis (*Ilia*) on the Peloponnese) attest to its spiritual reach, its financial robustness, and the communication maintained between the isolated monks and the inhabitants of the neighbor-

ing islands and coastal areas. Manuscripts were produced and copied at the Monastery's fully functional scriptorium. An early printing press and a library replete with notable volumes were also to be found alongside valuable icons and heirlooms—most of which were destroyed during successive raids or were carried off to foreign lands. Throughout its long history, the Monastery has remained an example of monastic life and a space for spiritual exercise, prayer, trials and tribulations.

Architecturally, the complex is considered one of the most important examples of fortified architecture on the Ionian islands and unique in Orthodox monastic architecture. Byzantine monasteries located in the countryside often have a fortress-like appearance, with a walled-in defensive enclosure, which is occasionally fortified by towers or turrets. The monastery buildings are usually attached to the insides of the enclosure, whilst the main church—the so-called *katholikon*—is located in the central courtyard. In the Strofades Monastery, however, contrary to the principles of traditional Orthodox Christian architecture, the central courtyard does not surround the *katholikon*, but stands empty in the middle of the monastery's four wings. The *katholikon* itself, the "fortified" Church of Transfiguration, is located inside a defensive tower in the South Wing, a unique arrangement in Orthodox architecture. Since there is no clear and incontrovertible evidence of its founding in the historical and archaeological data collected so far, the complex's successive construction phases have been largely identified through the available archival sources, travelers' testimonies, the inscriptions found on the monastic buildings themselves, and on a wider understanding of the architectural history.

Given that, the Monastery's history and construction may be divided into three periods: the first stretches from the early 14th century until about the year 1500; the second spans the centuries of Venetian rule (1500–1797); and the third one dates from the fall of the Republic of Venice to the present day.

The stavropegic, royal Monastery of Strofades was initially dedicated to the Virgin Mary, Joy-of-All (*Theotokos ton Panton Charà*), otherwise known as the *Lady of Strofades*; and subsequently to the Christ Pantocrator. The iconostasis' sacred diptychs depict the Byzantine Emperor of Nicaea Theodore I Laskaris (1175–1222) and his wife, or daughter, Eirini, as founders of the Monastery. From an archaeological point of view, there are sections of the complex that can be dated back to the late Byzantine period and, despite the aforementioned absence of evidence attesting to its exact founding, further indications corroborate the Monastery's existence during the late Byzantine era:

Two papal letters dating back to the end of the 13th and the beginning of the 14th centuries confirm the presence of a Latin ecclesiastical

administration on the "St. Mary of Trofares" (an obvious corruption of the name "Strofades") which belonged to the western order of Benedictine monks. We are, unfortunately, in no position to assert how long the Benedictine monks stayed on the islands. Subsequently, documents belonging to secular rulers and several travelers' narratives from the beginning of the 15th century testify to the islands' falling under the Venetian authority of Methoni, which was apparently responsible for bailing out captive monks and for constructing a fortified home that could withstand pirate raids. According to one particular traveler's description, in 1420 the Monastery was inhabited by more than fifty monks who seemed to be following the Orthodox monastic tradition. Later tradition has it that the Byzantine Emperor at Constantinople, John VIII Palaeologus, (1392–1448) renovated the Monastery in 1440, and yet we have no indisputable historical evidence pertaining to the frequent change in local politics, or its effect on the Monastery's status. From the middle of the 16th century and until the end of the 17th — and later on, especially during the 19th century — the Monastery was fully flourishing, witnessing intense building activity and a bolstering of its defense capacities and resources, despite sporadic hostile raids.

During its centuries-long life, the complex has been destroyed and plundered during raids by Turks, Algerians, and pirates. It has also been worn down by repeated and intense seismic activity, by its proximity to the sea, by having been abandoned for long periods of time, and by the structural faults perpetuated by erroneous repairs and interventions. In 2009, under the auspices of the *Metropolis of Zakynthos & Strofades,* the Laboratory of Urban and Spatial Planning at the Department of Architecture of the University of Patras designed a research project that would conserve, architecturally restore, and showcase the Monastery Complex. The project has been approved by the Ministry of Culture and now awaits funding. Its intention is to bring about specific interventions that will highlight the architectural, structural, and morphological identity of the monument.

In addition, the planned modernization of the existing port facilities will ensure visitors' access to Stamfani itself, where one will then be able to enjoy a unique religious, archeological, and environmental-themed walk. Contemporary wanderers, like the wanderers of old, will be charmed by a monastery which was "… richly adorned with elegant and wonderful buildings, sacred vessels in gold and silver, sturdy carriages, large and small boats, and all other decorations befitting an earthly Paradise."[1]

1 Chiotis, (1858), p. 535.

Dramatis personae

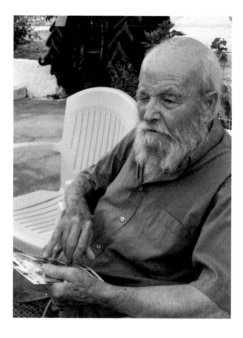

Father Gregory. Last monk of the Holy Monastery at Strofades
(September 13, 1937–July 31, 2017)

Father Gregory Kladis was born in Agalas, a mountain village in Zakyn-
thos, in 1937. As a child he kept to himself, not being prone to socializ-
ing. He was ordained a deacon in 1965 and a presbyter (priest) in 1967.
At the beginning of the 1970s he visited the Monastery on Stamfani,
staying there for six months with Father Porfyrios, who had been a monk
there. In 1976, after a trip to Mt. Athos, he decided to return. He stayed
true to this singular life-decision for 38 years, from 1976 to 2014 when,
due to serious illness, he was forced to return to Zakynthos. Father
Gregory essentially lived with God, on the largest of these two islets
in the Ionian Sea, a guardian of the historic Monastery, its wells and
churches, and its unique natural landscape.

 During those 38 years, Father Gregory suffered hardship, illness
(he always cured himself) and a lot of earthquakes. He would leave the
islands twice a year, once on the feast of St. Dionysios (August 24),
patron saint of Zakynthos, who was also a monk at Strofades and was
originally buried there, and once more in order to bring back supplies
from the Holy Metropolis on Zakynthos. On November 18, 1997, when
the massive 6.6 Richter earthquake hit the area with its epicenter on the
Strofades—causing incalculable damage—Father Gregory was on one
of his rare visits to Zakynthos. Was it luck, or something else?

 Father Gregory came back to the Monastery the very next day. He
found severe damage to the buildings, including cracks in the roof, but he
never considered leaving. Up until 1985, when the lighthouse at Strofades
(built during the English rule, 1809–1864) was still manned, he would
help out the keepers and keep them company. When the last keeper left
Stamfani sometime during the 1990s (the lighthouse having been long
automated by then), Father Gregory was the only living soul on the island.
His only systematic encounter with another human being was his meeting
with Labis Kalofonos who, weather permitting, would drive his boat on
behalf of the Seat of the Monastery at least once month to the island,
carrying supplies and provisions. In winter, when the south-eastern wind
(Sirocco) was blowing furiously, 50 days could pass without a visitor....
So, Father Gregory was self-sufficient and frugal. He rarely ate meat and
he had his own production of milk and cheese. He would also live on

greens, which he loved. He had his farming work and absolutely adored his animals. He was essentially a farmer-monk.

Even though he never graduated from primary school, he liked reading and working with his hands. He was tough on himself. A kind and helpful man to all who would visit the Strofades, it is said that he always handed out the cheese he made in a round shape to visitors, offering to make them coffee. But he truly enjoyed the company of only very few people. Even those who came to know him closely speak of the difficulties of penetrating the soul of such a special and deeply free man, who felt himself so close to God and to nature.

Father Gregory came to be acquainted with Robert McCabe's photographs of the Strofades on three separate occasions, a few months before he passed away. The first two times were in Athens, in May 2017, before and after the heart valve replacement surgery he had to undergo. Nurses and doctors report of his great perseverance and patience during this ordeal. "I am too sinful and too unworthy to give you my blessing," he said to hospital staff who'd asked him to bless them. The third time was on Zakynthos, in July 2017, almost 2 weeks before he died at the house of Kostas Kefallinos, "the Moscovite," his trusted and beloved friend, a frequent visitor to the islands who cared for the old man with exceptional love and care until his very last breath.

Looking at and commenting with great clarity on the series of photographs of his beloved Strofades, where he devoted his life and to which—he seemed to understand—he would never be going back, Father Gregory unfolded his life story, both his own everyday life as a farmer-monk at the historic fortress/monastery, as well as the everyday lives of his predecessors, who had lived there collectively, also as farmer-monks. But above all, he uttered a deep cry, similar to Robert McCabe's tender, penetrative, photographic glance—a cry against the abandonment of this historical fortress/monastery, this unique example of a "fortified church" in the entire Christian Orthodox world, which is now in danger of collapsing, dragging with it almost 8 centuries of life inside its walls. The image of the Tower church supported by wall ties and lateral restraint bars and wires, and the sense of decay, indifference, and desolation conveyed by McCabe's photographs brought Father Gregory to tears: "If it falls now, it's a lost cause. It can never be rebuilt. You can never rebuild something like this …" he said during the most touching moment of his encounter with images of the Monastery.

Labis Kalofonos. Boatman, Supplies Carrier to the Strofades Islands
(born January 13, 1953)

He was born 65 years ago in the village of Pantokratoras in the munici-
pality of Laganas, in Zakynthos. He comes from an agricultural family.
He first visited the Strofades islands in 1969, as a 15-year-old, on a
fishing trip with his uncles. "I fell in love with those islands as a kid,"
he says. Having completed his military service in 1975, he started visiting
the islands more frequently. At the beginning of the 1980s, he made the
acquaintance of Father Gregory, the last monk on the Strofades. "He
singled me out from the rest of the visitors," Kalofonos remembers.
"I would go up to him and help him out when he was making cheese,
or cutting hay, or harvesting the wheat before the threshing; I knew of
these things because of my family. I would even go over during winter
time, when no one else visited the islands, and so I decided to rent a
boat for myself and carry supplies to Father Gregory on behalf of the
Holy Metropolis, with whom we'd made a deal." From 1988 until 2005,
Labis would visit father Gregory at least once a month, carrying olive
oil, wine, petrol for the generator, fuel, fertilizer, and whatever else might
have been needed. "I put up a VHF receiver at home and planted an
antenna close to Laganas, and Father had his own VHF too, and we'd
chat every evening at around 8 to 9 pm, just before he went to bed.
Sometimes he would fall asleep as we were talking. He wasn't an easy
man to communicate with. I often had to force him to do it. 'I don't
have as much need to talk as you do,' I used to say to him."

Dimitris Stithos. The last keeper of the Strofades lighthouse
(born August 12, 1949)

The man who was the last to lock the door at the lighthouse at Strofades
—marking its switch from manual to automatic operation and, with that,
the end of an era—was born in Volimes, a village in the north of Zakyn-
thos. His wasn't from a family of lighthouse keepers, but of farmers.
But, following the example of many of his fellow villagers, who selected
this occupation at a time when people often got only a primary education
and everyone's financial needs were great, he graduated from primary
school and then sat the exam that allowed him to become a lighthouse
keeper for the Navy, in the beginning of the 1970s. For years to come,
he manned many lighthouses all over the Aegean, in the Cycladic
islands, in Lesvos, and other places. He served at Strofades during the
1980s and the 1990s, first with 5 other keepers—when the lighthouse
was still manned—and then alone. The first 6 or 7 years after the 1985
automatization, Dimitris Stithos was the sole operational supervisor of
the lighthouse.

 The last keeper of the lighthouse would receive visits and supplies
from Zakynthos every 15 days. He felt, nonetheless, self-sufficient. At
some point during the 1990s, he received an official letter from the Navy
telling him his service at the Strofades lighthouse had come to an end.
So when the time came, he locked up the lighthouse, said farewell to
Father Gregory, and left Strofades. He was transferred to the Katakolo
lighthouse in the prefecture of Ilia (Elis), on the opposite shore, to what
became his last post before retirement. From all his 27 years as a keeper,
his fondest memories are those of the Strofades, he says. He loved
hunting there; he was in the company of his wife and of an "exceptional
priest, very conscientious, very easy-going": Father Gregory, the last
monk on the islands.

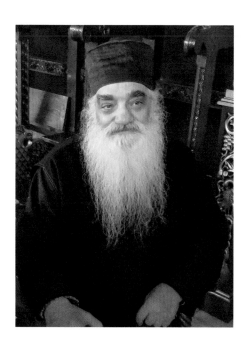

Archimandrite Dionysios Liveris. Abbot of the Holy Monastery of Strofades & St. Dionysios in Zakynthos (born January 27, 1939)

Father Dionysios was born 79 years ago in Keri, a mountain village in the south of Zakynthos. Even though one finds many monks with the name "Liveris" in the archives of the Monastery, he was the first in his family to go into the service of the Church. Father Dionysios exhibited a love for the divine from a very young age. He was a regular cantor at his parish church. And having a great affection for ecclesiastical books, it wasn't long before he "felt nostalgic for"—as they say—a monastic schema. On February 22, 1967, at the age of 28, he was accepted as a novice into the Holy Monastery of Strofades & St. Dionysios, whose Seat had been transferred to Zakynthos together with the relics of the Saint in 1717, after a savage pirate attack against the Strofades islands. On June 27 1971, he was ordained a hierodeacon (deacon-monk), and on August 6, 1981, he became a presbyter (priest) and the Abbot of the Holy Monastery of Strofades & St. Dionysios.

When he assumed his duties at the current Seat of the Monastery, in Zakynthos, 20 people were serving there as monks. Today, in 2018, there are only 9 monks left. "Most of us are old men. Only two or three are young. There're not enough of us to go around responding to visitors' needs, especially during the summer months, when the church stays open all day and we do multiple shifts in order to be of service to all those who want to come and worship."

According to Father Dionysios, when he first arrived at the Monastery in 1967, the Holy Metropolis (Diocese) of Zakynthos and Strofades —under whose jurisdiction comes the Monastery of Strofades—used to send monks to Stamfani every two years, to minister as priests. They would also send labor staff to help out with farm work. "Now there are no more souls or hands of men there," he says.

The lay of the land

Katerina Lymperopoulou

"This is, indeed, a very beautiful little island. I never beheld a spot so favorable to Pan, and the Naiads, and the Nereids, ποντίας ἀκτῆς ἔπι.[1] Here are tangled branches and flowering turf almost to the ocean's edge, and here are shades and shelter, and caves and myrtles, and silence and secrecy...."[2]

That's what the British historian, traveler, and priest George Waddington (1793–1869) wrote in an 1820 letter to "T" after an enchanting breakfast in the courtyard of the fortified Holy Monastery of Strofades at the invitation of the Abbot. ("T" was the British historian, bishop Connop Thirlwall, who was his classmate at Trinity College, Cambridge.)

Strofades—the islets of winds and sanctity—stand in a central area of the Mediterranean, 27 miles south of Zakynthos and 28 miles to the west of the Peloponnese. The largest of the two islets, Stamfani, has a length of about 4900 feet and a width of 2800 feet, and the smallest of the two, Arpia, is only 2800 by 1100 feet. The name dates from antiquity: both the Greek geographer Strabo[3] and the Roman writer and naturalist Pliny[4] used the name Στροφάδες or Strophades in their writings.

The poetic admiration expressed by Waddington for the flora of Stamfani is entirely justified. In the past, these two islets were considered among the most fertile in Greece. Here one found gardens whose fruit could nourish the monks who lived at the fortified monastery, whose history—according to archival sources—goes back to the 13th century, and which is now listed as a historical monument.[5] Today there are still fruit trees on the island, surrounded by wild vegetation. All in all, one can identify 250 different species of plants and flowers. There are also natural springs and wells with potable water, although many have been damaged by the frequent earthquakes in the area.

The Strofades are a nature reserve belonging to the National Marine Park of Zakynthos (NMPZ). More than 1200 species of migratory birds, bound to or from Africa, rest and nest on these islets. The Strofades are also an important breeding ground for seabirds. Several species of shearwaters (called *Artinia* in Greek) make their nests here, so the islands are also known as "*Artinonisia*," the islands of the *Artinia*. Yelkouan shearwaters (*Puffinus yelkouan*) nest here, as well as Scopoli's

shearwaters (*Calonectris diomedea*), which have built their largest colony in Greece here. On Stamfani, apart from the Monastery's two churches, there are the chapels of St. Nicholas and St. John, as well as an imposing lighthouse at its western end—erected when the Ionian islands were under British rule. The Strofades' anchorages are poor and port facilities non-existent, so the islets are often inaccessible.

The Strofades are a unique monument to nature, culture, and faith. Their 800-year-old monastic complex—geographically and architecturally unique of its kind, a monument of great historical and spiritual value—stands still, despite pillaging, raids, disasters, and earthquakes. The November 18, 1997 earthquake (6.6 magnitude on the Richter scale) caused enormous damage. It is imperative to immediately intervene and restore the monument.

"I do begin at last to feel myself in Greece," wrote Waddington in his letter in May 1820[6] feeling the cool breeze and the northwest mistral—tame by the time it reaches Greece—blowing in through his window overlooking Zakynthos and the coast of the Peloponnese.

When he visited the Monastery of Strofades, the islands were under British rule, and the 40 monks living on Stamfani were said to be paying rent to a Zakynthian nobleman who owned the islets. About a hundred years later, in 1914, the German writer and traveler Josef Ponten reported only 15 monks living at the Monastery. A few decades later geologists C. Anapliotis and P. Psarianos speak only of four monks in 1963, and just one in 1976. That one was the last monk of Strofades, Father Gregory, who served the Monastery for 38 years, until 2014, and is a central figure in our narrative.

1 From Euripides, Hecuba, 778: "on the sea shore."
2 Waddington (1829), p. 194.
3 Strabo, Γεωγραφικά, vol.8, ch. 4.2: «κατὰ δὲ τὴν παραλίαν ταύτην τῶν Κυπαρισσιέων πελά-γιαι πρόκεινται δύο νῆσοι προσαγορευόμεναι Στροφάδες.»
4 Pliny the elder, Naturalis Historiae, vol. 2, book IV, ch. 19, par. 55: "ante Zacynthum in eurum ventum Strophades duae, ab aliis Plotae dictae."
5 ΦΕΚ (Government Gazette) 194 vol. B 28/2/1980.
6 Waddington (1829), p. 185.

1 Here's where I lived, by myself, for 38 years. I first came here for just a few months, then visited Mt. Athos and came back for good in October 1976. I lived here all alone until February 2014. They say I'm a difficult man. Maybe that's what a loner looks like to them. The weather could be terrible in Strofades at times. The wind could pick you up, take you all the way to … Gaddafi, on the opposite shore.
I remember once, this well-known man from Zakynthos—he'd come around quite a few times already—was on his boat with friends. It was night. They were going 'round and 'round the island, they couldn't get into port. They'd come to catch woodcocks. When they finally made it to land, they hugged and kissed each other.
FATHER GREGORY

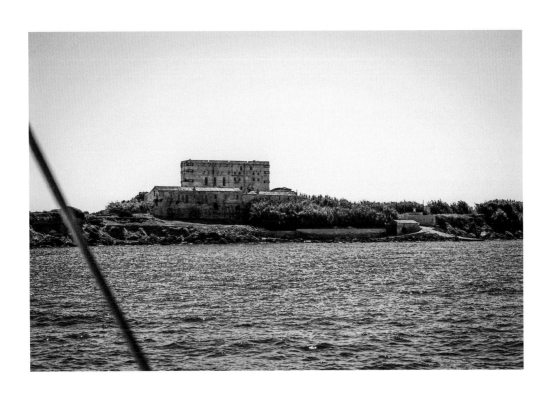

2 This picture is taken right in front of the port. You can see the Monastery and the Tower in the back and in front you can see the boathouse where the old monks, the ones before me, used to house their fishing boats. It was half gone, but they rebuilt it.

FATHER GREGORY

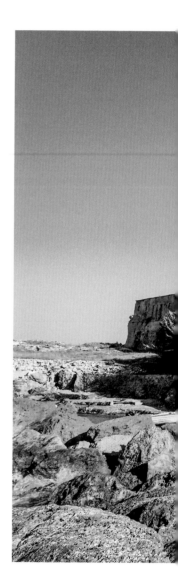

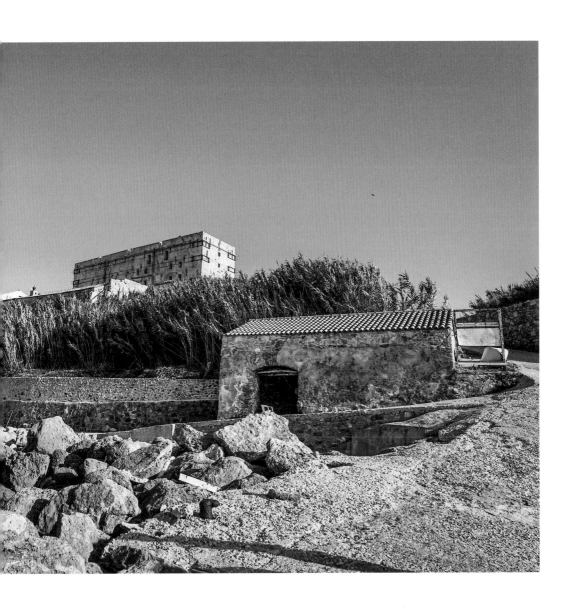

3 This sign shows where the island lies relative to Zakynthos. I used to go to Zakynthos once a year for supplies and once for the Saint … but I'd hurry back.
FATHER GREGORY

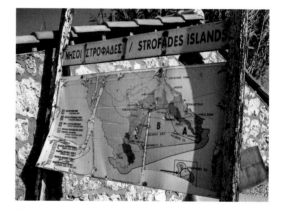

4 Here's the dock, also known as *Tarsanàs*. That's where the boat moors when it comes here from the "outside" world—but only when there's no wind. The road that leads to the Monastery starts here.
FATHER GREGORY

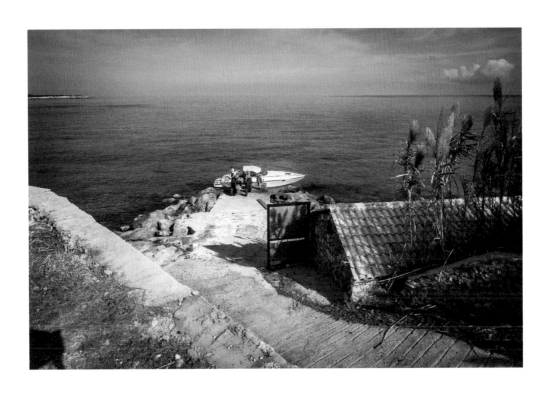

Strofades: A miracle in the middle of nowhere

His Eminence Chryssostomos, Metropolitan Bishop of Dodona

The Holy Monastery at Strofades is a miracle in the middle of nowhere. It connects East to West and acts as a valuable beacon, in historical and religious terms. The monument was consecrated by none other than Saint Dionysios, Archbishop of Aegina, patron saint of Zakynthos, who was buried in the chapel of St. George within the monastic complex of Strofades on January 17, 1622. His body was found intact, whole, and fragrant. After the Strofades were violently raided by Turkish pirates in 1717, his sacred relic was transferred to the island of Zakynthos. The Seat of the Monastery was temporarily transported to Zakynthos too, and it remains so today. The Central Archaeological Council of Greece has approved the research project that was drawn up by the University of Patras, under my own mandate as Metropolitan Bishop of Zakynthos, in 2009, for the restoration and the promotion of the monastic complex at Strofades, which was fatally wounded by the extreme intensity of the 1997 earthquake. Yet the project never materialized. We are trying to implement the project amidst a storm of derision and unfulfilled promises from every government that has taken office since then. What would it take for it to be implemented? What our ancient ancestors used to say: δει δε χρημάτων, it takes money. So many EU funding programs have just overlooked us....

5 That's the statue you can see in
the courtyard, erected in the mem-
ory of the monks slain by the Turks
in the old times, on one of their
many raids. Their bones lie in the
chapel of St. John, one of the four
churches on the island. Three are
chapels: the chapel of St. George
inside the Monastery; the chapel
of St. John, with the monks' bones;
and the chapel of St. Nicholas.
And then there's the main church
built into the Tower, dedicated to
the Holy Transfiguration.
FATHER GREGORY

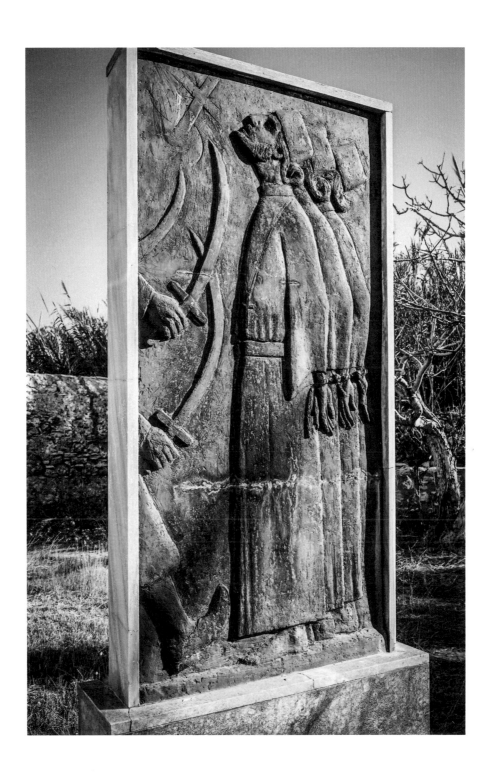

6 In front of the courtyard. You can
see the Tower and the entrance gate
to the Monastery. To the left, right
next to the Tower is the *goumenio*
(the Abbot's quarters) of which one
window is visible. On your right,
there's the run-down kiosk. It had
loads of functions. We've even used
it as a kitchen.
FATHER GREGORY

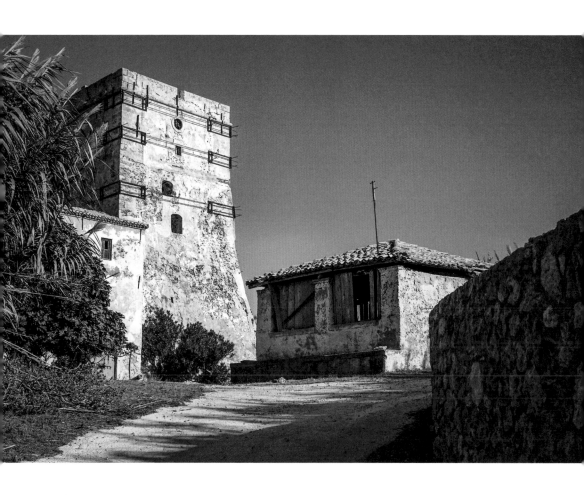

7 The Tower is 69 feet high. That's
what some people who measured
it told me at least. There's a model
of the Monastery at the Museum
(of the Holy Monastery of Strofades
and St. Dionysios) in Zakynthos.
Ask them, and they'll show you it.
FATHER GREGORY

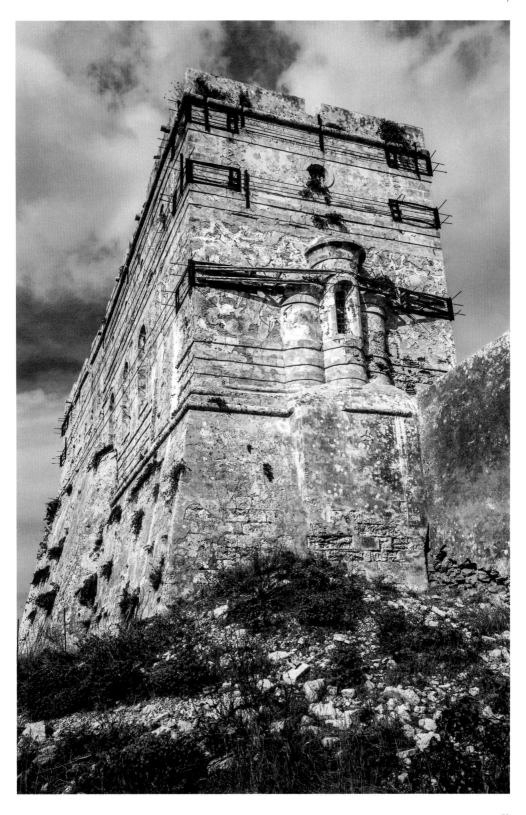

8 Father Gregory would wander around the island, but he had a purpose. He'd walk the length of the island together with the sheep. He was, essentially, a shepherd; he loved the animals. For the longest time he used to thresh in the traditional way, using animals. But later, the shipowner Konstantinos Vernicos gave a threshing machine, and we'd thresh with that. I used to see father Gregory once a month, more or less. I'd bring over supplies by boat from the Metropolis of Zakynthos and Strofades. To live like this, all alone, on this rock, that was the choice of a lifetime. No, he wasn't afraid. I'd say to him: "Priest, what if something happens to you?" And he'd reply with a smile: "So what? The motherland will have one child less."
LABIS KALOFONOS

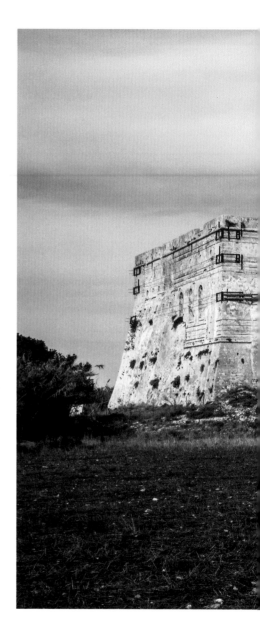

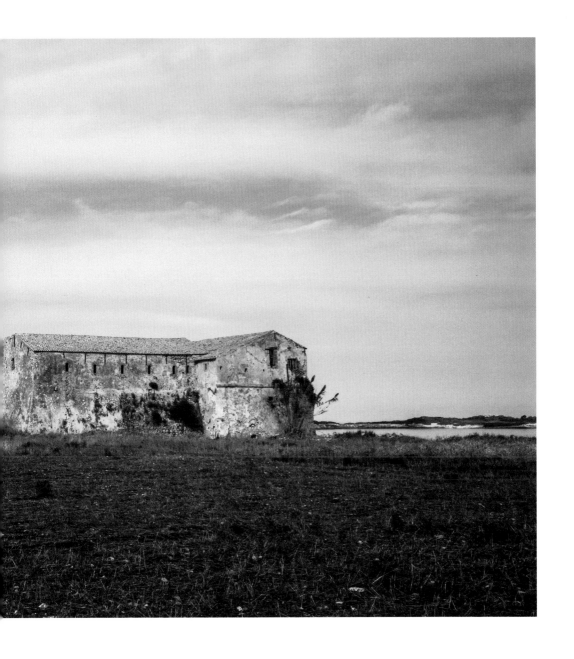

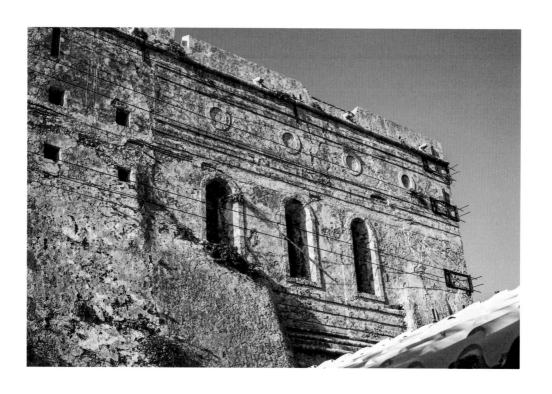

9 Look at those old "belts," as we call them, on the Tower! There, where the big windows are, there lies the church. Half the Tower is taken up by the church, the rest is storage spaces. There're 3 wooden floors. They used to store the wheat there. Then they'd wash it, take it all the way to the roof of the Tower to let it dry and, before the rains came, they'd push it through a hole in the back of the Tower, back inside. I've only heard about these things. It's what the monks used to do before my time. These holes are battlements.

FATHER GREGORY

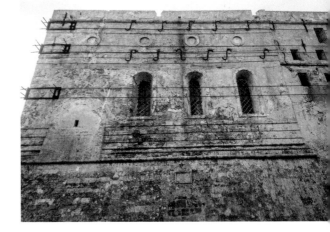

10 Do you know how the old ones used to call these anchor plates? "Arpezes" they're called. They're washers with tie rods, there to keep the building safe, not just for earthquakes, in general.

FATHER GREGORY

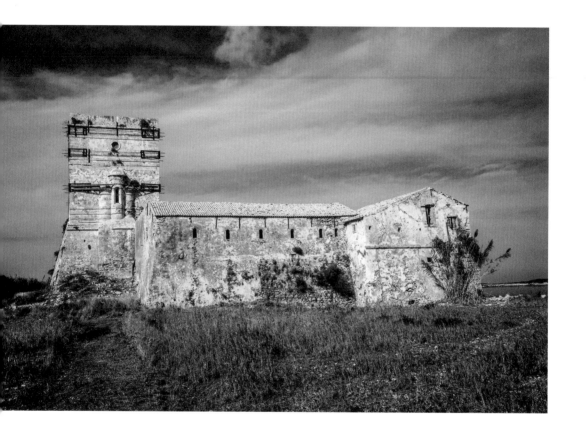

11 There were monks, there were lighthouse keepers, there were other employees there in the old days. It was full of life, full of animals. Now there are no more souls or hands of men there.
ABBOT DIONYSIOS LIVERIS

12 Once upon a time, it was really difficult to visit the Strofades: a long and arduous journey. Now we are living in the Age of Technology —not that technology is a bad thing, it's just that Man has used it only for bodily reasons. So he's used it for comfort, and to eliminate distances, but he's forgotten he's not just a body, but there's more to him, there's this part of man that—as St. Basil of Caesarea says—is infinite, his soul that is.
ABBOT DIONYSIOS LIVERIS

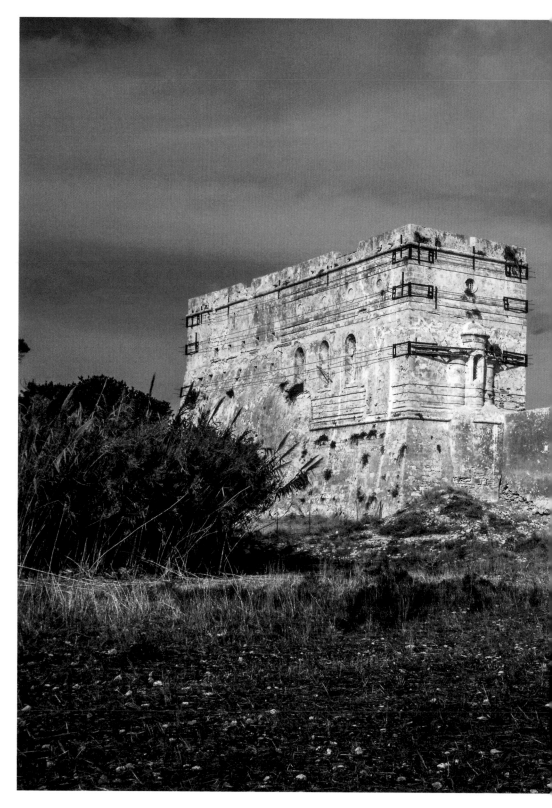

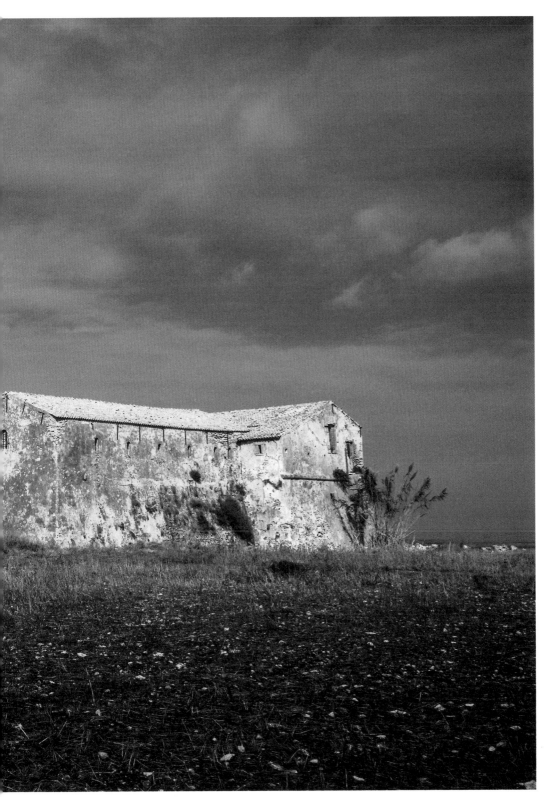

13 Here is the sole entrance to the
fortified church of the Monastery.
Before Father Gregory moved to
the island, the monks would live
there on a 2-year rotational basis.
One at a time, alone, for 2 years.
I remember this lack of people on
the island. But Father Porfyrios has
said that there were 4 monks living
in the Monastery during the 1950s.
In the '70s, and before Father
Gregory came along, it was Father
Potamitis—bless his soul—who
stayed on the island; I'd see him
every time I went there fishing.
They had a boat at the Monastery
then, with sails and all, and it
would only go out 5 times a year.
LABIS KALOFONOS

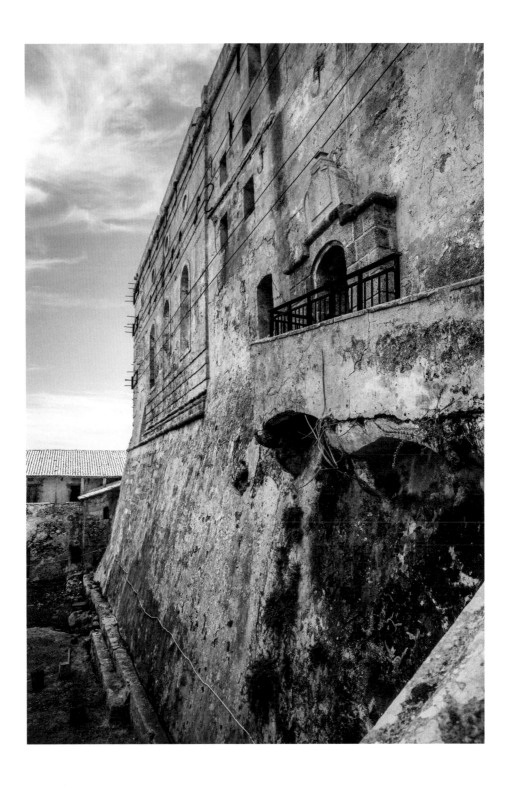

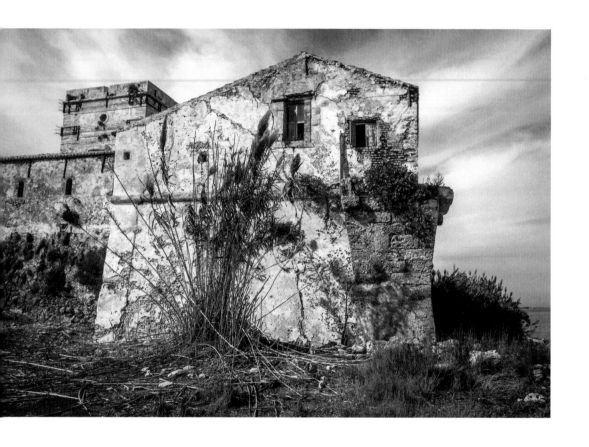

14 This is the last cell on the east wing
of the Monastery. I moved here
after the earthquake. The small
window is the window to my cell,
the large one, the corridor window.
I chose this cell because it had no
cracks or fissures. I'd have to walk
through debris to get to this cell.
The last years, when my legs
became too weak for the stairs,
I moved to the trailers. The plant
you see under the small window is
capers. I used to pick it, boil it, put
it in vinegar, and eat it.
FATHER GREGORY

15 On Strofades, there are certain
hours during the day that you
just can't forget. Like when the
sun dips into the sea. If you go sit
down on the bench at that hour,
and you gaze towards Zakynthos,
you'll never forget it, for the rest
of your life....
FATHER GREGORY

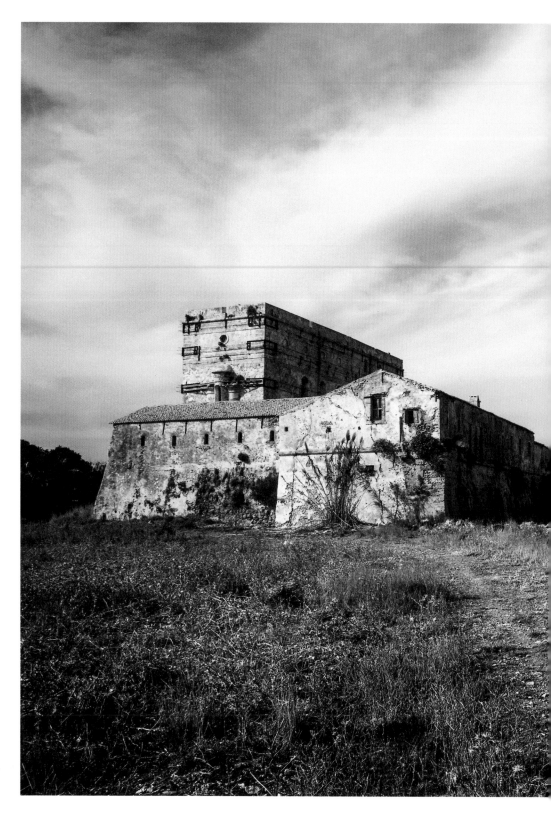

The Holy Monastery of Strofades:
A unique structure in the Orthodox World

Dr. Stamatios T. Chondrogiannis

What makes the monastic complex at Strofades so unique — at least for the Orthodox Christian tradition — is that the *Katholikon*, the central worshipping space, the main Church dedicated to the Holy Transfiguration, is within the defensive Tower of the complex. The necessity of a defensive construction for monastic complexes outside city walls was something self-evident in those times, of course, for obvious reasons, as is well evinced by the monasteries in Mt Athos and other places. The Holy Monastery at Strofades is, however, unique within the religious and monastic canon because it has an *entirely* defensive character. It is for this reason that the church itself is a fortified tower. There are many examples of fortified monastic complexes as such, but none quite like this one.

16 That thing on top of the building
—can you see?—it's some sort
of an addition. It was damaged
pretty bad by earthquakes. It
seems that because of the heavy
weight of that upper part (*the
addition*), because of the vibration
from the earthquake—you know
how the earth moves, right-left?—
it might split and open it all the
way down again. These wires you
see, they put them up after the
big 1997 earthquake, which did
huge damage. His Eminence (the
Metropolitan Bishop of Dodona,
Chryssostomos) sent over a team,
which injected concrete in various
parts of the Tower and then put up
the wires so that the Tower would
not fall. But it was supposed to be
a temporary solution. If the Tower
is not supported in a more perma-
nent way, it'll fall at the first
earthquake.
FATHER GREGORY

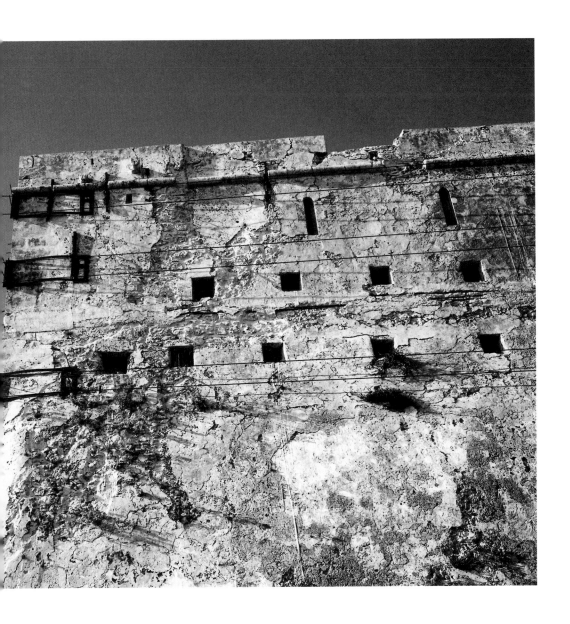

17 When the earthquake hit, I was on the Strofades without the priest. I'd stayed behind to look after the animals. I cannot begin to describe what it was like. It was 3 in the afternoon, and it was drizzling. I was with Father Porfyrios, who was serving at a *metochion* on Cephalonia; he had been serving on Strofades for two years, long before Father Gregory moved here, and he had said he wanted to come down and remember the good old times (he'd come now and then, on short visits). I have never seen such an earthquake in my entire life: the beams fell on me, the planks fell on me. I grabbed father Porfyrios—who was limping, he had lost a leg to diabetes—and dragged him out, I don't even remember how we did it…. And we got out and then the second earthquake hit and I saw the Tower swing to and fro, like the reeds during a gale! And it didn't fall. I thought I'd see it coming tumbling down, but it didn't. It was a miracle!

LABIS KALOFONOS

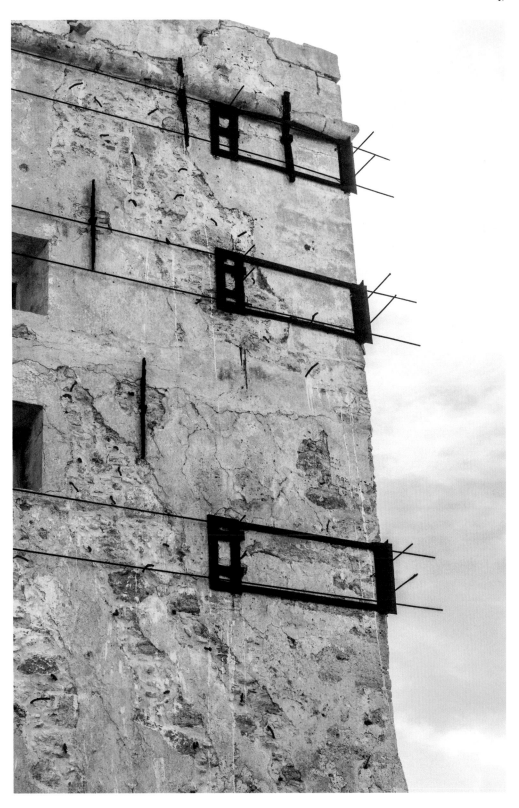

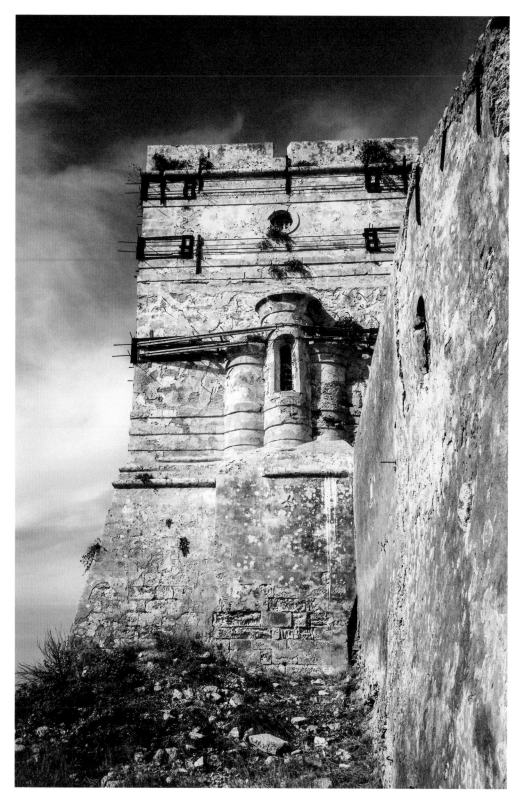

18 I remember we'd visited Strofades with someone from the Ministry, after the big 1997 earthquake and I recall him saying: "What a monument this is! Please, father, take my card, and call me every now and then to remind me of it." Well I did, I reminded him of it, but to no avail, my child.

ABBOT DIONYSIOS LIVERIS

19 I happened to be on Zakynthos when the big earthquake hit in 1997. For supplies I used to go to Zakynthos once a year. I'd stay with the Saint (i.e. at the Seat of the Holy Monastery on Zakynthos) and then I'd come back. On one such visit I'd gone with Father Gerassimos to see an olive grove, ravaged by the winds. And then he says to me: "why don't we go up Skopos mountain to take a look at the Strofades?" So we did. And as we were climbing down, it happened, with an epicenter on Strofades. I felt something "dragging" my feet down; it was the earthquake. My eyes were glued on the belfry (of St. Dionysios, on Zakynthos). It was moving to and fro, to and fro. On the very last move, the bells sounded. Oh, how I thought of the Strofades then! Who knows what's happening there, I said to myself. I went back the very next day. Why would I be scared? I stayed there until February 2014, when I left for Zakynthos. I stayed there 38 whole years.

FATHER GREGORY

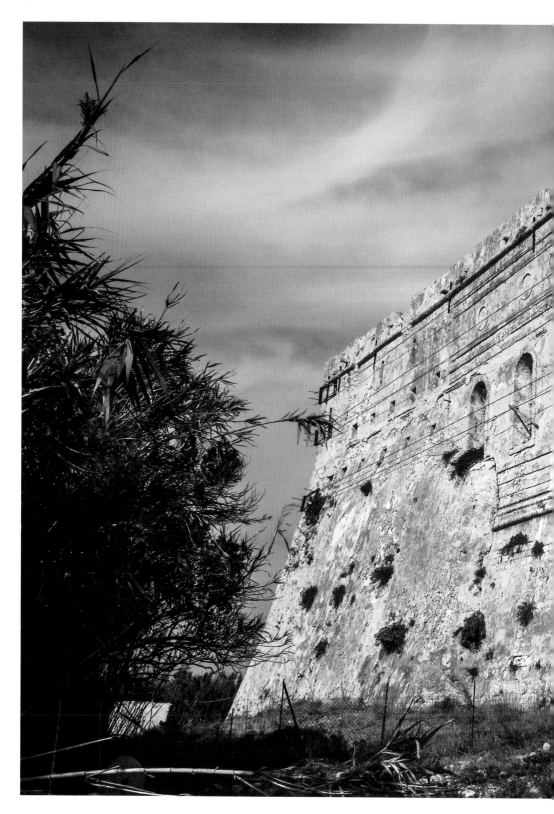

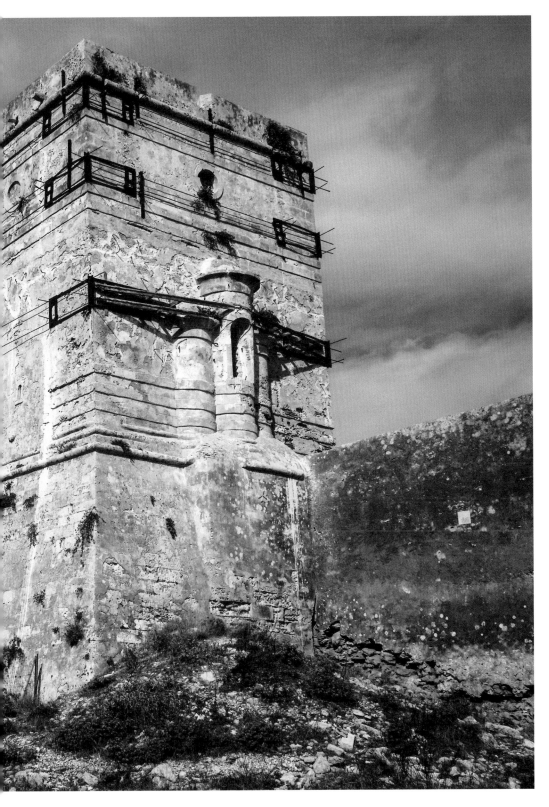

20 This is a monument that's withstood earthquake upon earthquake throughout the centuries. It's been built so well, it still stands.... Yet now it's an empty ruin.

ABBOT DIONYSIOS LIVERIS

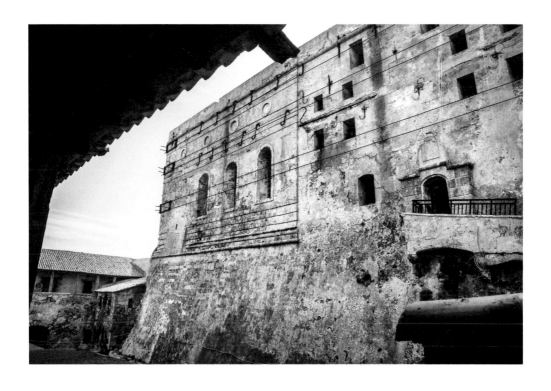

21 This is one of the containers—at
52.5 feet each—that the Church
brought over from Zakynthos, to
house the men who'd work on
restoring the Monastery after it was
damaged in the 1997 earthquake.
There were three of them and they
were placed in an L-shaped forma-
tion. You can see the water tank.
I never stayed in them. I re-entered
the Monastery after the earthquake
and not once was I scared it would
fall on me. And when my legs got
too weak, I moved to the trailers.
We'd only go back to the bakehouse
to bake bread. The Abbot's quarters
stayed empty.
FATHER GREGORY

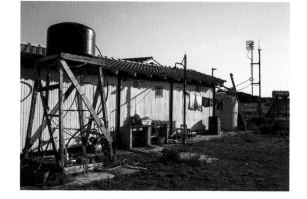

22 We'd give our heart and soul down
there. I've fought with the sea and
half-drowned many a time. Do you
know what it's like trying to sail
down there in November, January,
February, March? Now the place is
abandoned. And whoever visits,
they visit in order to take, not to
give anything back....
LABIS KALOFONOS

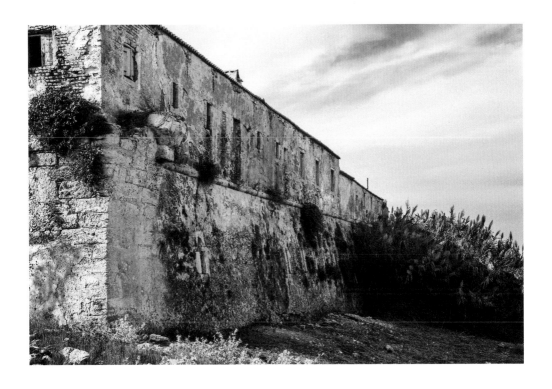

Monasticism as military service. The Monastery's manuscripts

Dionysios I. Moussouras

The Strofades Monastery was founded as a "stavropegic" monastery, that is, under the auspices and jurisdiction of the Ecumenical Patriarchate of Constantinople and it remained so throughout the Ionian islands rule by the Republic of Venice. It was thus a constant reference point towards the Orthodox east. This Monastery was a defensive rock. The monks at Strofades performed a quasi-military service and had to use weapons to defend themselves and the Monastery against frequent pirate raids and other attacks. The freedom to exercise their monastic duties was often paid in blood. A traveler's testimony suggests that, up until the 1500s, the Turks did not dare approach the Strofades. That changed; the Turks came. The Holy Monastery was fiercely attacked during the 16th century, but it was restored every time, in order to carry on with its precious—to the local region—operation. Every time the Monastery was destroyed during some Ottoman-Venetian war, for example, the Venetians would pay for it to be restored; you see, it is an excellent point from which to observe the movement of enemy fleets. It's also a useful naval supply base.

The operation of the Monastery was quite idiosyncratic—yet another element that adds to its uniqueness. At no point was the Strofades Monastery an example of cenobitic (i.e. communal) monasticism. Each monk lived and ate in his cell, but they all came together to worship in the church embedded within the Tower. Another noteworthy difference with respect to other monasteries of the time is that the courtyard does not surround the *Katholikon*—the main church—but extends in an elongated shape in the middle of the four wings of the complex.

The oldest manuscript in the Monastery's scriptorium is a copy of *The Souda*, a massive 10th century Byzantine Greek historical encyclopedia of the ancient Mediterranean world, from 1465. Yet the majority of the Monastery's manuscripts are ecclesiastical. Today, the manuscripts of the Holy Monastery of Strofades are scattered in libraries around the world. Most of them are found in the Biblioteca Marciana in Venice. Others can be found on the island of Serifos, on Zakynthos, even in the Library of Alexandria, whilst a lot have simply gone missing. All original

Strofades manuscripts carried a cryptographic note in the back, reading *των Στροφάδων εστί* ("belonging to Strofades"), a proprietary inscription to safeguard stolen manuscripts from appropriation.

Researching the history of the Monastery means conducting investigations into its spiritual activities. But these are not written down: how many people found God, how many believed, how many underwent confession…. Its spiritual reach, however, is evinced by the fact that it possessed *metochia* (ecclesiastical embassies) on Zakynthos, Cephalonia, the Peloponnese, etc. This was not a matter of economic power. The Strofades Monastery's immense spiritual authority stemmed from the presence of the relics of St. Dionysios. And even if we cannot trace this authority through written, archival sources (the Monastery had no famous ecclesiastical authors and St. Dionysios himself did not write anything), the very fact that the Monastery possesses a scriptorium is proof in itself of its spiritual importance.

According to Leonidas Ch. Zois, a historian from Zakynthos, the Monastery not only served as a customary guesthouse for Patriarchs and Metropolitan Bishops, but also as a place of exile for convicted clergy. Gradually, the Monastery's importance diminishes, as evidenced by the dramatic decrease in the number of resident monks during the 20th century. This decline should be attributed to ideological, cultural, and economic reasons. If more sources and information turn up, one might be able to draw a brief and complete history of the Monastery in the future, something that's not happened yet.

It would be a shame for a structure that's withstood the test of time and the raids of conquerors such as the Venetians, not to be able to be maintained by its current "owners."

THE MONASTERY ENTRANCE

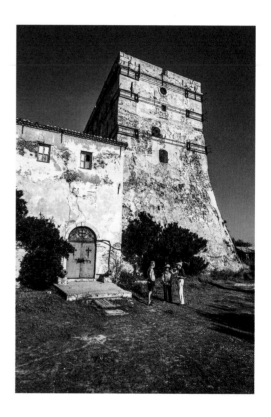

23 This is the door, the entrance.
The Monastery's gate. There used
to be cannons on the parapets.
FATHER GREGORY

24 You can see the two remaining
ones at the gate of the monastery.
FATHER GREGORY

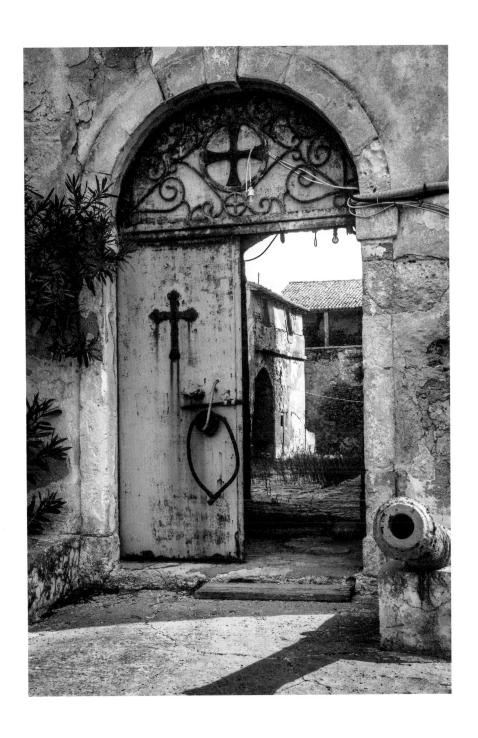

25 This is again the gate and the Tower. As you've been told, the Tower is tied up with iron cables, so that it doesn't open up at the seams, at its corners. There was a sort of exit as you'd go up the staircase to the Tower all the way to the roof. It was open for a long time.
FATHER GREGORY

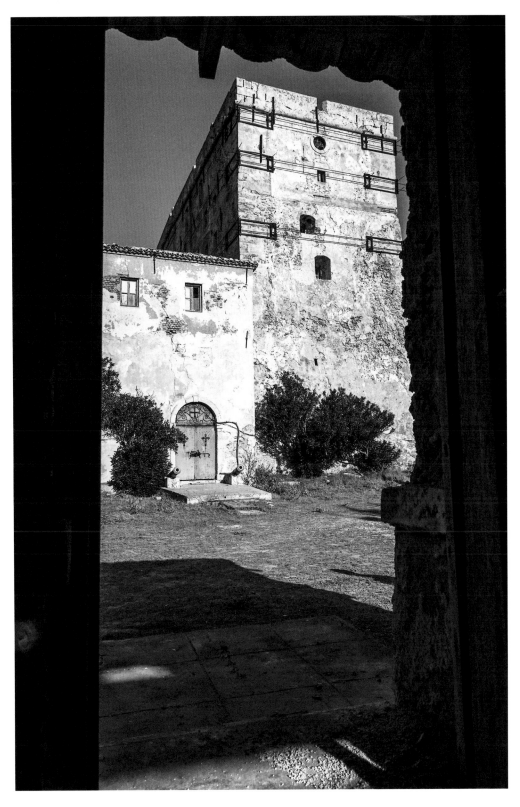

26 This is a detail from the
Monastery's gate.
FATHER GREGORY

27 This is the inner door to the
Monastery. I think these planks
were meant to be on the ground
and then someone picked them
up and shaped them into what
looks like a door and put them
in the place of the old door.
FATHER GREGORY

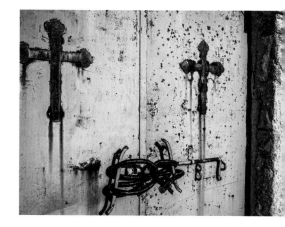

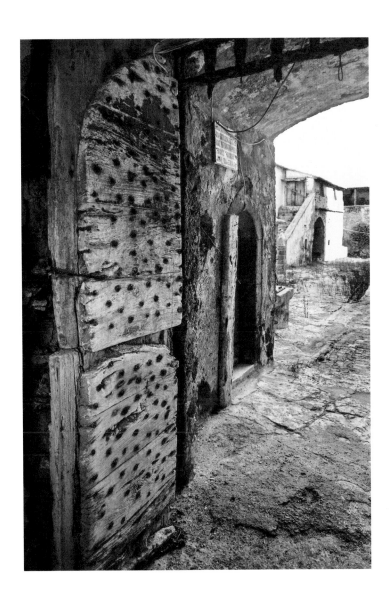

28 The stains on the inner door look like bullet holes, but they're just nails they used either for the harrow, or on the ground. This door is made of really thick wood.
FATHER GREGORY

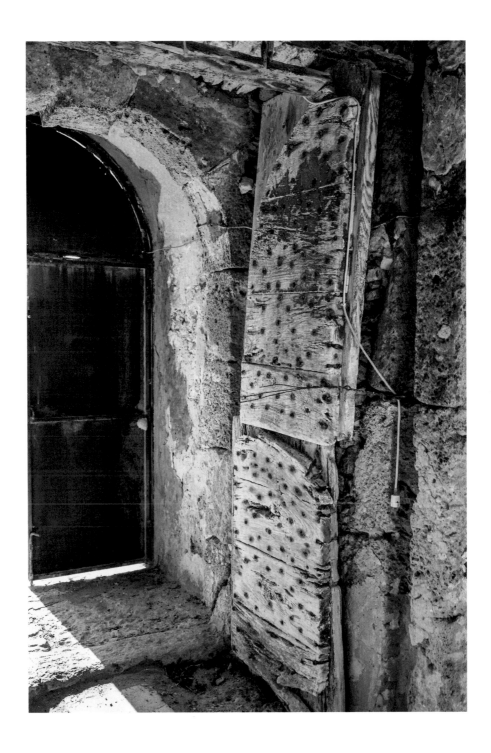

29 It was I who had this sign painted. Because everyone who alighted here wanted to leave his mark, his name. I remember these men, they came from Kyparissia, and the very first thing they did was to find a plank and write their names on it. After I put the sign up, people stopped writing. It was the Abbot's nephew who wrote it. No, it's not an old sign. I told him to write it thus: not "do not write" but "you are requested not to write." I haven't studied, I didn't even graduate from primary school, but I like reading. I have missed reading. I like the *kathare-vousa* (Formal Greek language that was introduced after the Greek Revolution and incorporated elements of ancient Greek spelling and grammar). I am now reading, for the second time, K. Simopoulos' book *Foreign Travelers in Greece, 1700–1800.*
FATHER GREGORY

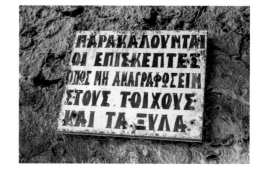

30 The portcullis was already out of
use during our time. But it is said
that in the old days, whenever they
saw an unknown boat going by,
they'd put it down. I don't remem-
ber ever seeing it down, nor do the
monks that were here before Father
Gregory, with whom I had a few
talks during my very first visits to
Strofades, 40 years ago or so.
LABIS KALOFONOS

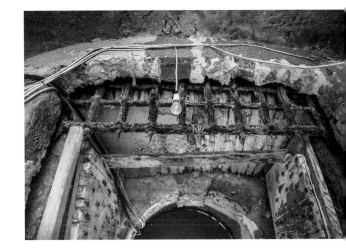

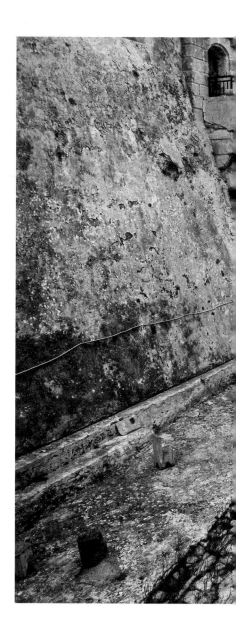

31 Before the 1997 earthquake, we'd
live in cells on the second story
of the Monastery, up there. We'd
cook and eat in the kitchen.
LABIS KALOFONOS

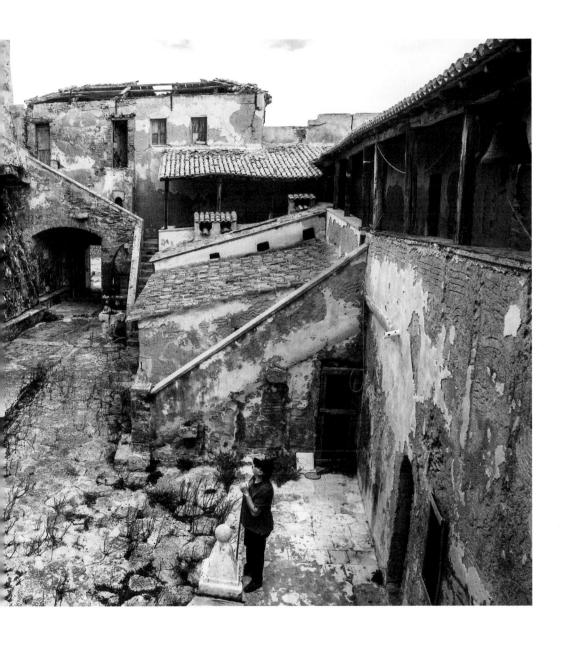

32 After the monks were slain in a raid, the administration, the Seat of the Holy Monastery of Strofades and St. Dionysios, was moved to Zakynthos. So we'd send a monk from Zakynthos to serve. When I first came to the Monastery, these monks would change every two years.

ABBOT DIONYSIOS LIVERIS

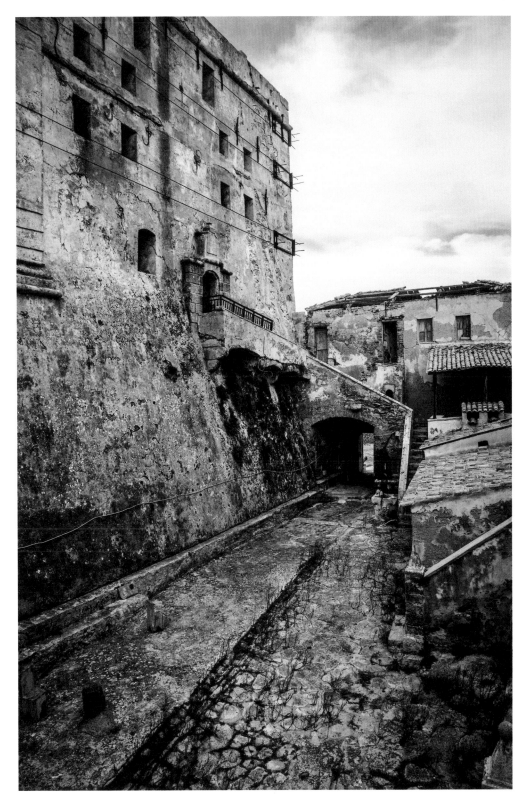

33 This was a monastery-fortress.
Do you see that gate, opposite?
If you look from there to here,
you'll see a hole in the entrance
to the *Hegoumeneion* (Abbot's
quarters) at about a man's chest
height. They say that in 1717,
when there was this famous
"Turkish raid" of the Monastery,
a deacon here killed 18 Turks.
LABIS KALOFONOS

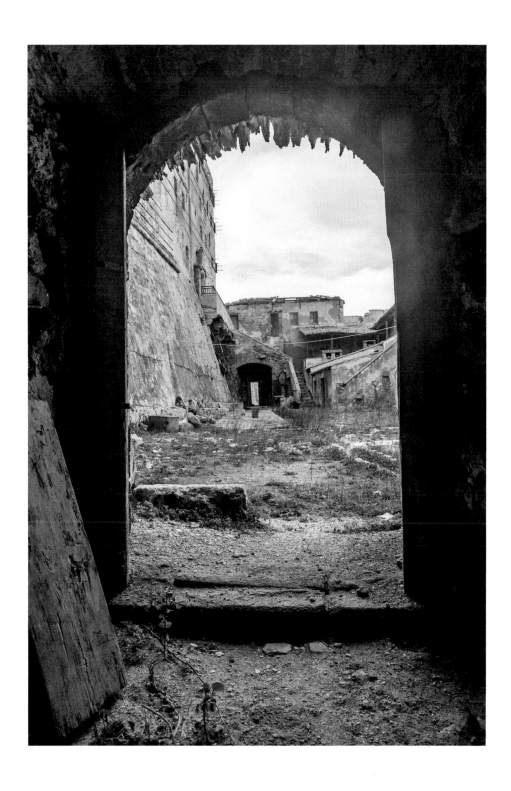

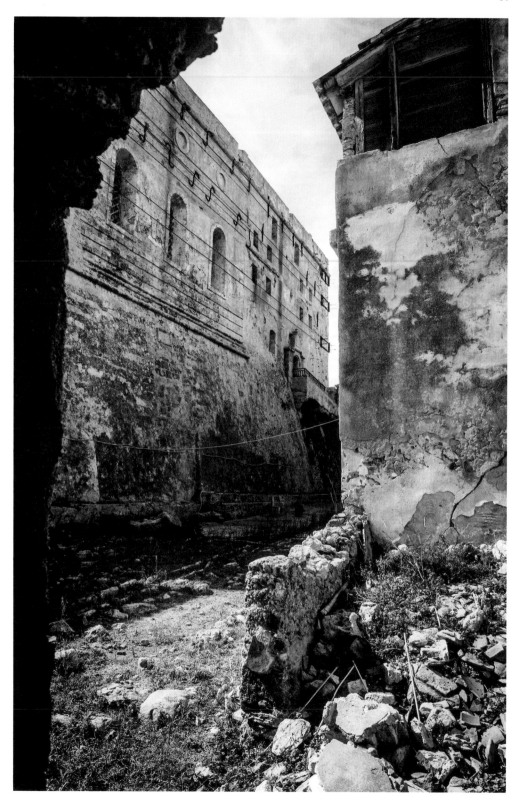

34 Very few times were there any
people around, living with me.
I remember being alone. I
remember being struck by a
teg (a sheep in its second year)
and thrown against a rock. I
split my head open but I healed
by myself. I put some rubbing
alcohol on it and it was fine....
FATHER GREGORY

35 You can draw a line from Gerakas,
the southernmost beach on Zakyn-
thos, all the way to Strofades....
I'd wake up every day and look
towards the horizon. I lived alone,
but I lived free.
FATHER GREGORY

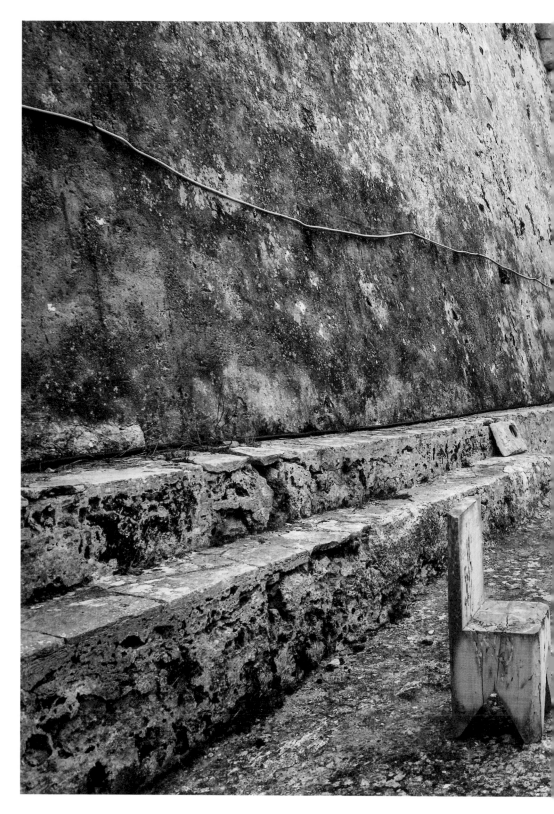

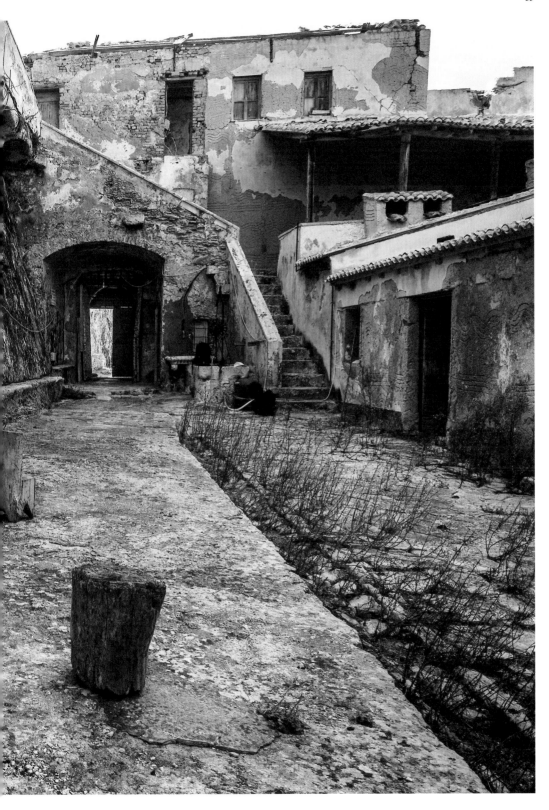

36 Yes, as you can see from the
pictures, everything's dilapidated
in this once lively courtyard of the
Monastery. I remember everything
in pretty good condition. And
outside the Monastery, the sheep
haven't been sheared for 3–4
years now and they get caught
in branches and they die.
LABIS KALOFONOS

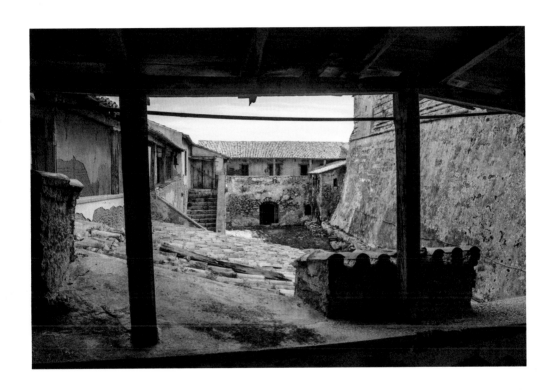

37 You need to have it in you to go
to Strofades, your soul needs to
be telling you to. Anyone moving
to the Strofades today would be
making a big sacrifice.
ABBOT DIONYSIOS LIVERIS

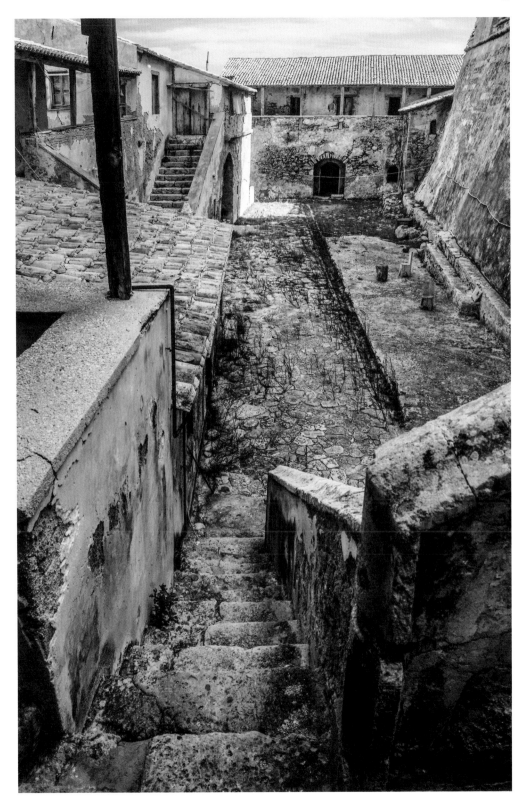

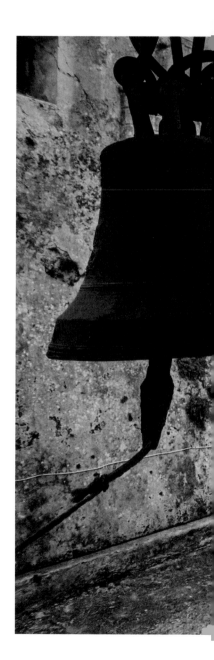

38 Father Gregory would use the bell, sure he did. He'd get up early, as always, prepare the sacramental bread, perform the *Orthros* (the last of the four Night Offices, before the Morning Service) and ring the bell so that I would wake up and go and find him in church, where he would be performing the *Orthros*.

LABIS KALOFONOS

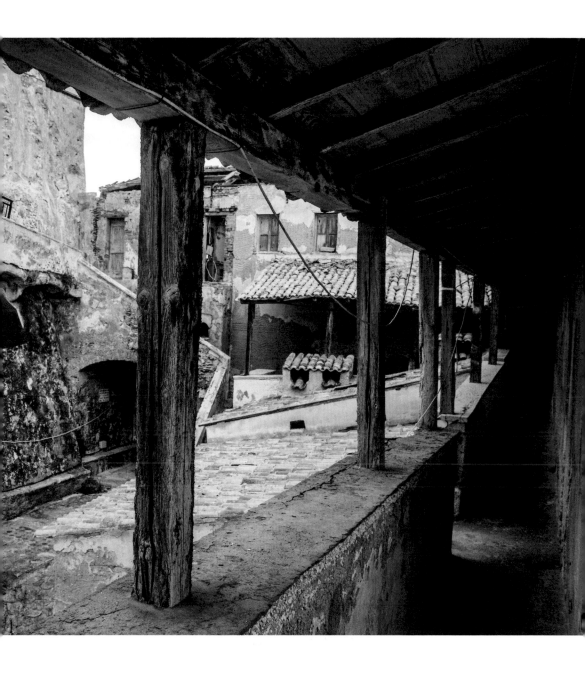

39 These are the ovens in the bake-house. The middle one could produce up to 60 or 70 breads at a time, depending on how many people were working it. This was like a small threshing floor. The oven over there on the side, the elongated one, was for food, for roasts. Don't forget that there used to live quite a lot of monks here once. This is the *gravalos*, the poker, to poke the coals with. This brown rug, I'd brought over from the church, to cover the bread, or the sour dough, until it leavened.... I used the right-hand oven myself. These two instruments are called *furnoconti*: they are peels, so you can shove the bread in and out of the oven. We used to have a mill once, so we could grind the wheat. We had a pony too, she would go around and around, grind the wheat and we'd get flour.

FATHER GREGORY

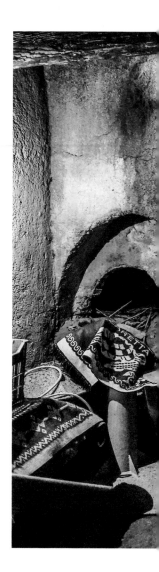

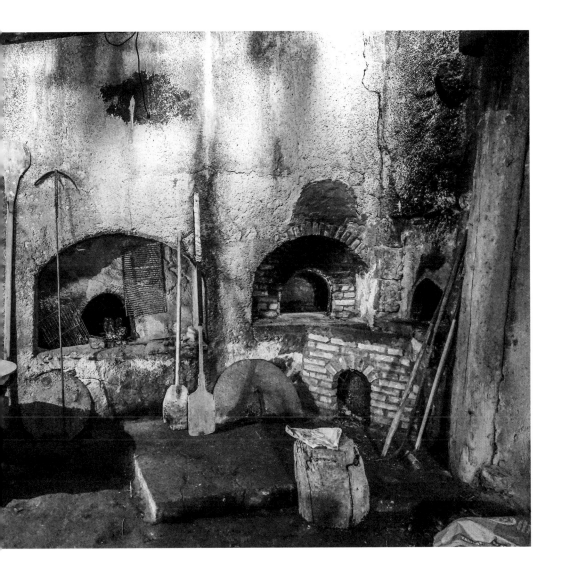

40 This is a warehouse and other storage rooms. His Excellency, the Metropolitan and other official visitors, had told me that the place reminded them of Mt. Athos. In this corner, outside here, they would store the cheese that the monks would make before my time. They had two pieces of wood, they would pull them out and lay on top the sacks filled with that creamy cheese, *prentza* (traditional, spreadable mixture of *myzithra* remains with olive oil and thyme). Ah, Strofades was the best dairy around!

FATHER GREGORY

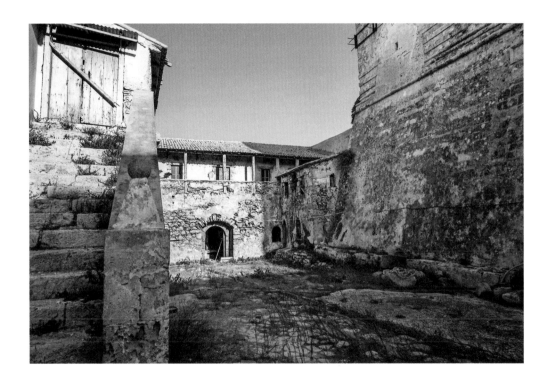

41 This is the room with the old mill. The horse would push these pieces of wood around and grind the wheat. I barely managed to see the animals work here. I remember a female donkey, that's it. And the sheep— now they're so few, compared to the old days.
FATHER GREGORY

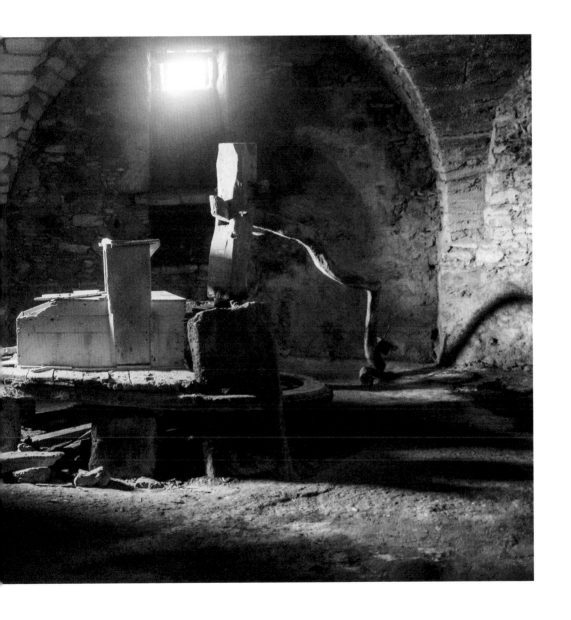

42 This is part of the old mill. Oh, these things have been lying around for years. At least since 1981....
FATHER GREGORY

43 Again at the mill room. The pulley and the gear. They'd make flour and then bread with this. This is where the wheat was ground. See the cogwheels? It's not been put to use for over 50 years now.
FATHER GREGORY

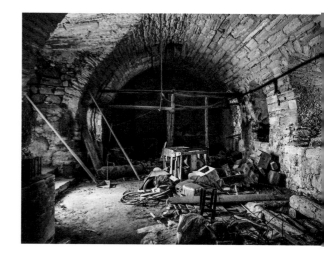

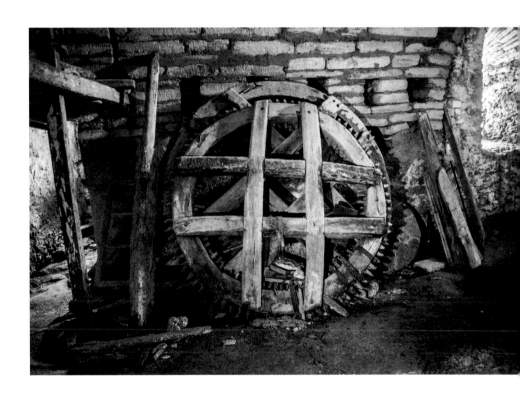

44 The door to the warehouse/
 storage room.
 FATHER GREGORY

45 The old monks used to grind
 peppers and stuff with this rock,
 long before me.
 FATHER GREGORY

46 This is a wheel from the old cart
 we used to transport stuff with.
 The Monastery had a cart, a horse,
 and donkeys in the old days. The
 lighthouse keepers used this cart
 as well, to move their things from
 the dock to the lighthouse.
 LABIS KALOFONOS

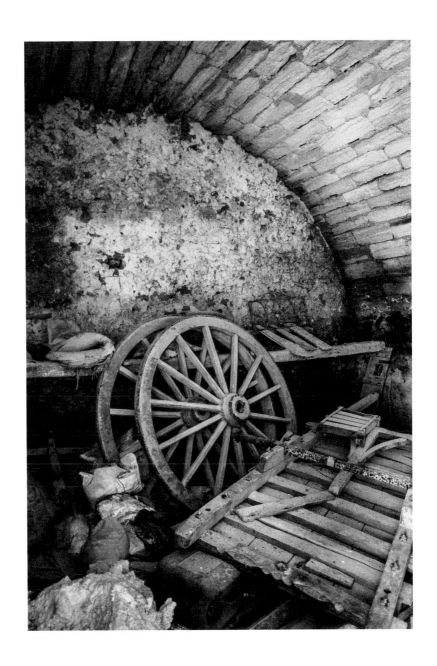

47 This is my tractor. They must have brought it to Strofades around 1984–1985. I had an older one, then they brought me this. They used to sow and cultivate wheat, common vetch, barley, broad beans, and peas with it. But I didn't know how to plough well enough. I used it as a vehicle, to move around. It was Labis who would come to plough, from Pantokratoras. He'd come and bring supplies and food. He'd thresh and harvest and he'd leave again. At some other point, I had Father Spourgitis come along. There were people that the Seat of the Monastery would send over, from Zakynthos. The Monastery had its own little boat called *Pantohara* (All-Joys). During my times, Labis would come on his boat, sent by the Seat of the Monastery, maybe once or twice a month, to bring supplies. But if the weather wasn't permitting it, he could stay away for three whole months, even. He'd bring me fuel, general supplies, and food.

FATHER GREGORY

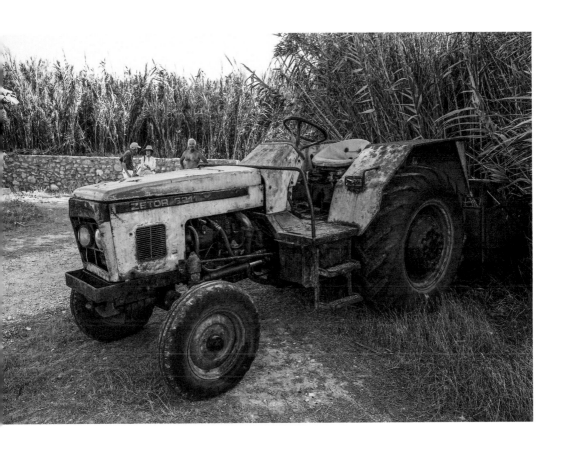

48 This is the generator that would power the Monastery with electricity. It'd often break down, due to dampness. The Strofades are a very damp place.
FATHER GREGORY

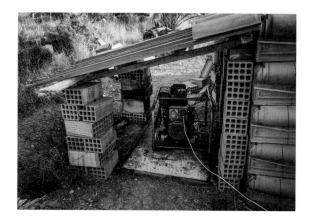

49 My *kareta* (wheelbarrow). I'd haul loads of stuff with it.
FATHER GREGORY

50 This is the Refectory. When there
were many monks around (i.e.
before his time) that's where
they took their meals. I never
ate anything in there. I would sit
in the little kitchen, the one with
the window, overlooking the rocks
and the horizon. The old Fathers
used to eat at the Refectory on
holy and official days. They even
laid a tablecloth when having
fish. They never ate meat in the
Refectory.
FATHER GREGORY

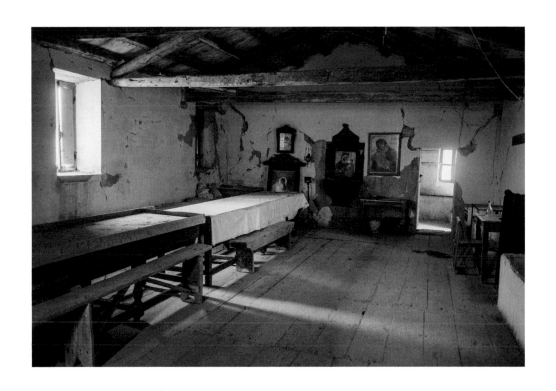

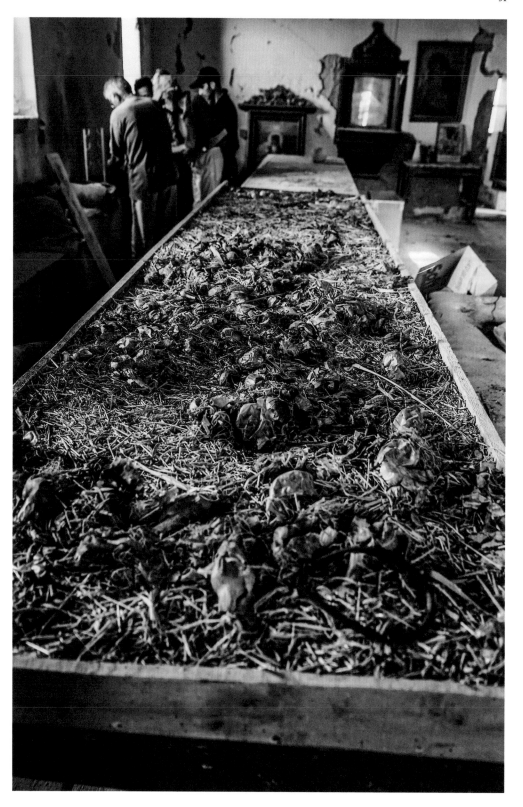

51 The Refectory 2015. These are
probably onions, on the bench.
FATHER GREGORY

52 I rarely eat meat. I like food I can
prepare by myself, like cheese and
greens. I liked to cook for my few,
good friends when they visited me
on the Strofades.
FATHER GREGORY

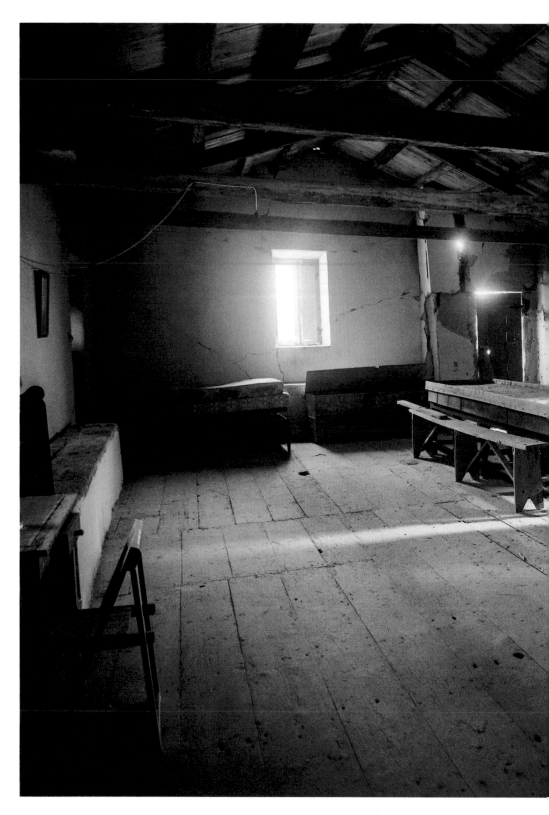

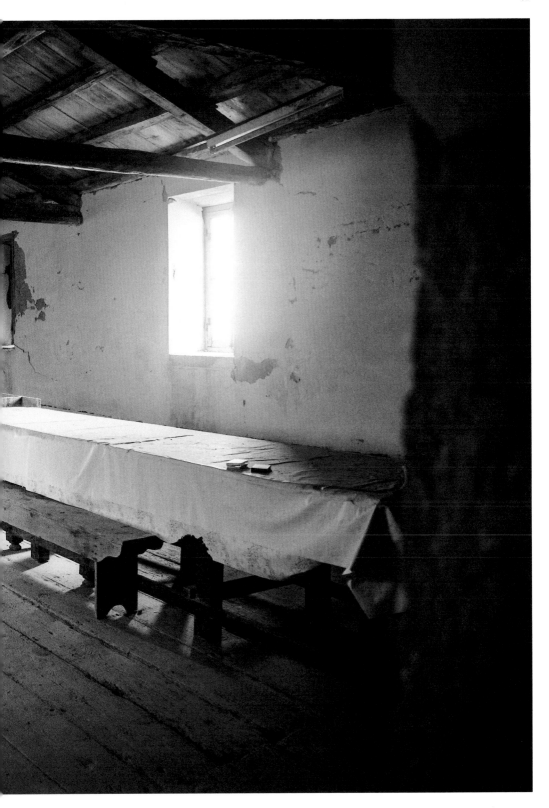

The Strofades Monastery:
An historiographic omission

Dimitris Arvanitakis

These rocks called the Strofades are a living monument to the history of the Ionian islands. Whoever studies the history of the Ionian will always encounter information about the Strofades, whether involving the life of St. Dionysios, the military conflicts, or the long history of piracy.

Constructing fortified monasteries was a staple of military architecture back then throughout the Greek world. On Naxos, Serifos, and Sikinos, in the whole of the eastern Mediterranean, one sees such fortified structures—more or less preserved—but the Strofades fortified Monastery is one of the oldest of them all, given that most of them date back to the Genoese or Ottoman conquest of the Aegean. It also presents a very rare fortified church.

The Strofades have not yet been studied in depth from an architectural, ecological, or religious point of view. All that we know is basically connected with Zakynthos' history. The Strofades should receive a more prominent and substantive treatment both within the history of Zakynthos and on their own. It is a serious deficit that there has not been so far more substantive research and that we don't have a comprehensive view of the history of this complex.

The imperative need for restoration of the Monastery and its salvation from threatened collapse could offer a unique chance not only for the rescue of a precious monument but also for more penetrating study of its history.

53 This is the chapel of St. George. We're looking down at the court-yard here; we're seeing exactly where the chapel is, where the relics of St. Dionysios were before being moved to Zakynthos. As we walk up the stairs, we meet the main entrance to the living quarters. My cell used to be here; it's where I lived before the 1997 earthquake struck. I always woke up early, about an hour before dawn. And at night, I'd never go to sleep before 9 pm. I had a clock, but I never paid much attention to it. We even had a TV. It did manage to get a signal, but I almost never watched it. I'd rather read at night and listen to the church service on the radio if I weren't doing the service myself.

FATHER GREGORY

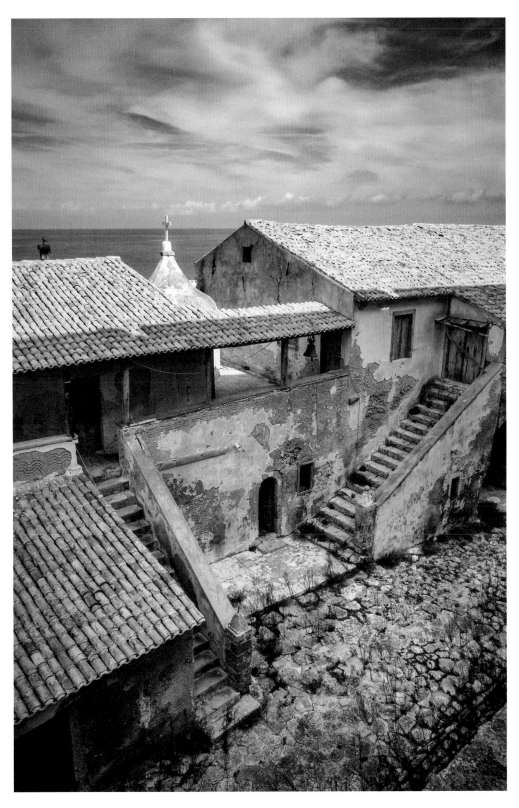

54 The old cupola, where the tomb
of St. Dionysios used to be, fell
during an earthquake in 1886
and it was subsequently restored.
FATHER GREGORY

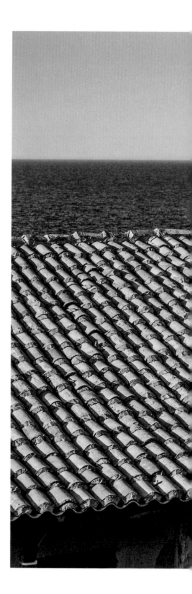

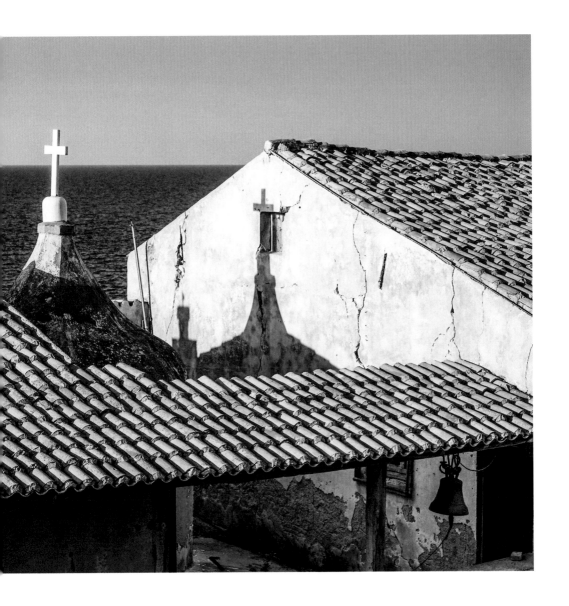

55 We would perform vespers and on
holy days we'd always have church
service inside the chapel of St.
George, by the Saint's old grave.
The priest had made me a cantor.
LABIS KALOFONOS

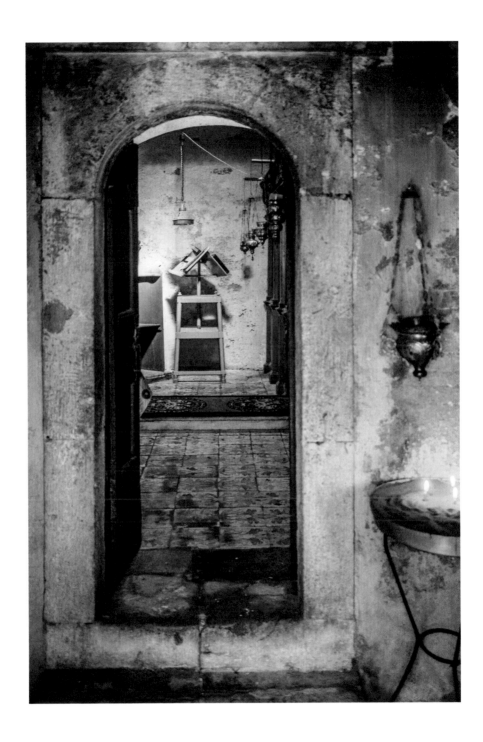

56 The inside of the chapel of St.
George, on the ground floor of
the Monastery. I used to come to
read here. I brought this hanging
vigil lamp from Mount Athos.
It burned on oil. Not petrol.
Olive oil. There were icons once,
but not anything too important.
I didn't find many heirlooms when
I came here in 1976, just ecclesias-
tical books. Most of them have
been taken to the Museum (the
Ecclesiastical Museum of the
Holy Monastery of Strofades)
on Zakynthos for safety reasons.
The chapel used to look beautiful,
with its icons, before the earth-
quake. The few valuable things
from the Strofades — like old icons
and old muskets — were locked up,
up until the middle of the 1980s,
on one of the stories in the Tower,
for safekeeping. Eventually, they
started taking them away from
1985 onwards, until almost noth-
ing was left. On your right, you
can see the icon of the Virgin
Mary Joy-of-All, which was
found here.
FATHER GREGORY

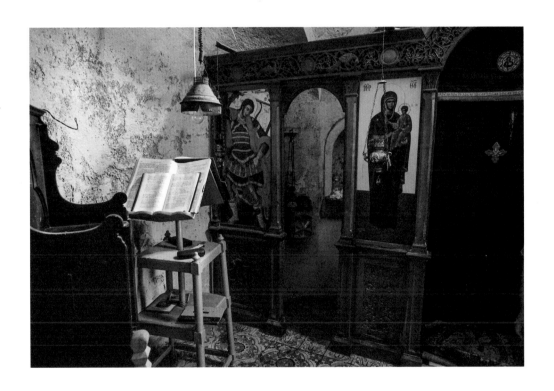

57 This is the Archangel George, also
known as "Master of the Canons...."
It's one of the icons that is not very
old. The heirlooms, as I said, had
been taken to Zakynthos.
FATHER GREGORY

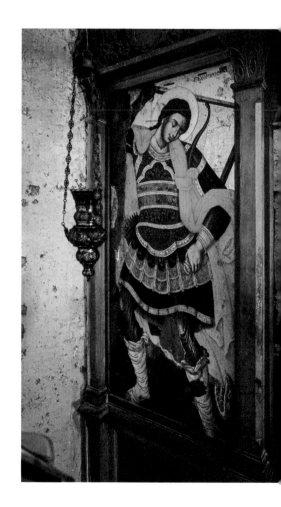

58 The Monastery suffered most
of the damage. The Tower stood
stronger.
FATHER GREGORY

Restoration prospects: "In conversation" with the monument

Dionysios Zivas

One certainly finds monasteries with a defensive character throughout the wider Mediterranean region—as is the case, for example, with the monasteries on Mt. Athos—but this is a whole different case: a rock, in the middle of the infinite sea, hosting a historic monastery/fortress? I don't know of anything else like it. The Strofades Monastery is unique. It is of utmost importance, hence, that it be reinforced structurally, so that it doesn't fall come next earthquake. It's as simple as that and that's our main goal. Any potential restoration has to be "in conversation" with the monument. And once we are certain we can fix it, then we start asking what functions it can serve. The long-term survival of the monument depends on its functionality. But first and foremost: it must be restored. And if it is, then it will mean a lot both on a Greek and a European level.

59 The door at the entrance of
the Tower.
FATHER GREGORY

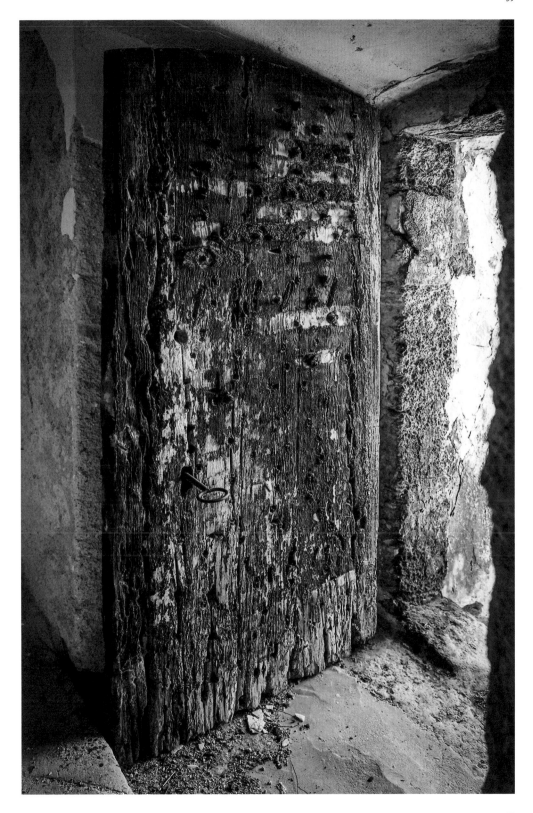

60 This is the emblem of the
Byzantine Empire: the double-
headed eagle. It's carved in
marble. Isn't it a shame to
have all this perish?
FATHER GREGORY

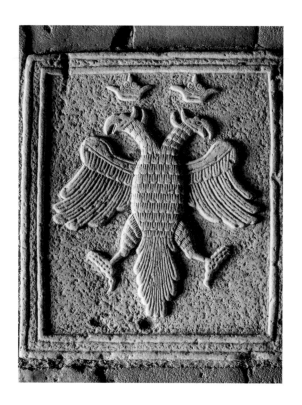

61 I recall there were some icons that had been gathered and placed here, in the first story of the Tower. Some foreigners came to see the Tower, I think they were Spanish. I told them to look around, but they were constantly looking at the icons, with great curiosity. I never let anyone come in here after that.
FATHER GREGORY

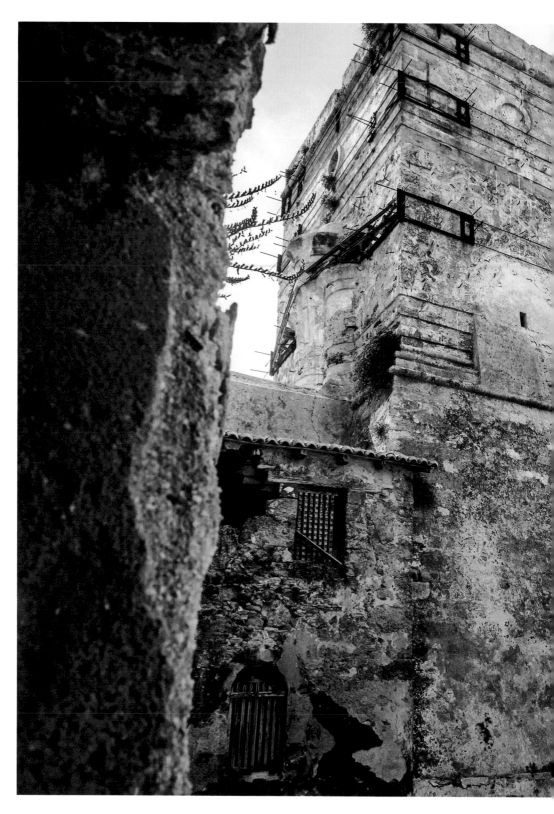

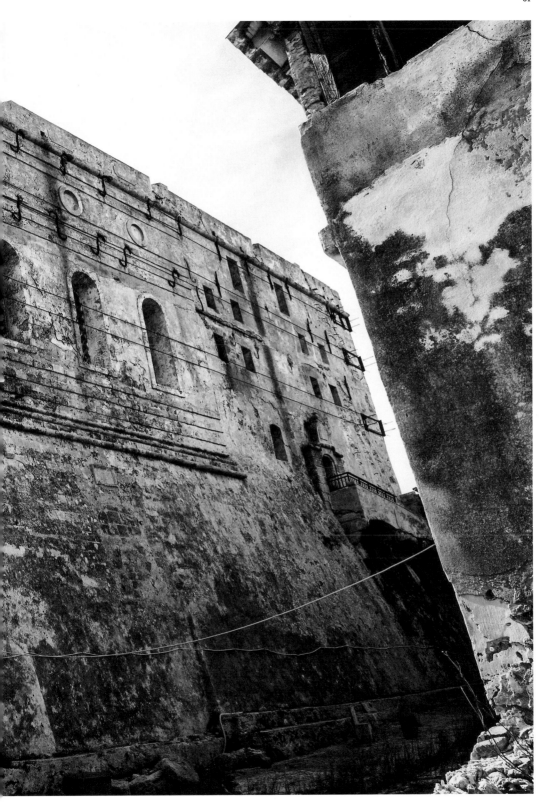

62 On the flat roof of the Tower, and on its entrance, you can see such signs, the signs of people who've come through here. Maybe these were carved with a *martelina*, the hammer they use on construction sites, people who know how to carve rocks.
FATHER GREGORY

63 This is the key to the Tower. I had these visitors once, they came to the Tower and they took it with them to Pyrgos, in the Peloponnese. It was on a table, right before I started the church service. I thought to put it away, keep it safe, and then I thought "nah … who would…?" In the afternoon, when they left, I went up to the Tower to lock and there was no key. I thought to myself, "I was right." And then we started calling Pyrgos to find out what had happened to the key. Then I received this call: "It's in that church, go get it…." It was them, who took it, they left it there so that they wouldn't have to come clean. People from Pyrgos; they did it …
FATHER GREGORY

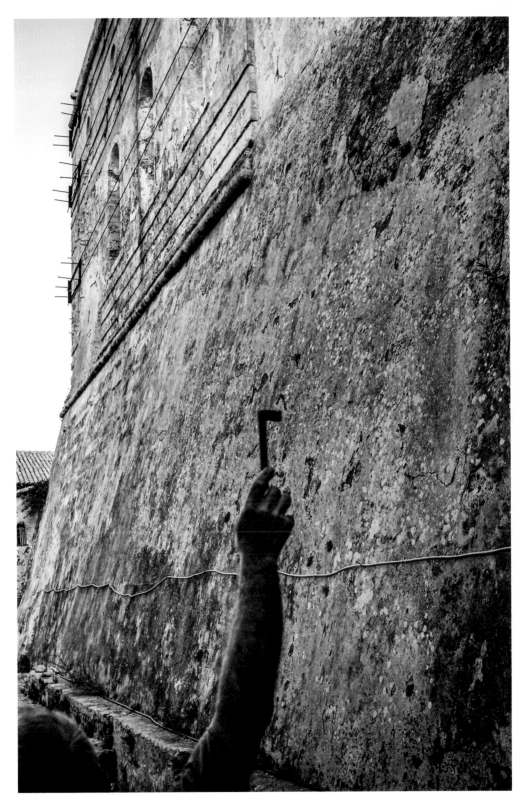

THE NARTHEX

64 This is the church inside the
Tower. We find it as we enter the
Tower and climb to the first story.
What we now see is what is in
front of the church, the narthex.
FATHER GREGORY

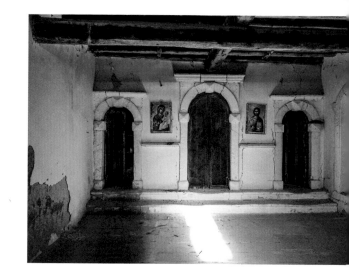

65 These are what we called the *bourdounaria* of the Tower, the strong, thick beams that make up the Tower's ceiling. These beams had been shipped here from outside Strofades.
FATHER GREGORY

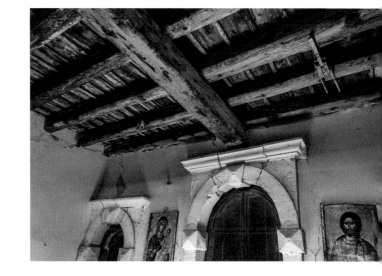

THE CHURCH INSIDE
THE TOWER

66 This is the floor of the Tower. You
can again see the double-headed
eagle of the Byzantine Empire.
FATHER GREGORY

67 Embossed, decorative details:
those before me lived a grand
life here!
FATHER GREGORY

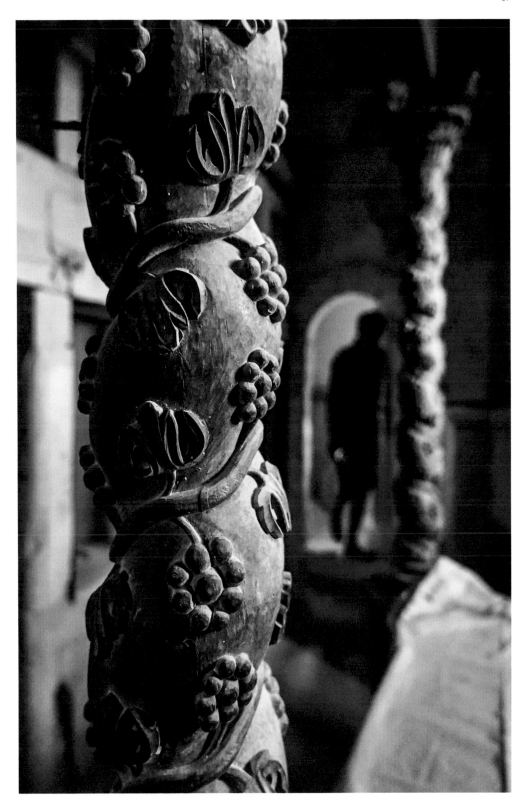

68 Parts of the Tower and the church were built around 1200 AD, I have heard. There were many icons inside the church. They've been taken to Zakynthos, to the Museum of the Holy Monastery of Strofades.
FATHER GREGORY

69 What you see here are details from the Tower church; the damage from the 1997 earthquake is pretty clear. The walls here are 13 feet thick. The windows are placed right in the middle of this great width, at 5.6 feet. After the earthquake, the Church would see services only during the big religious holidays or when there were visitors around. During Easter, for example, when friends from Zakynthos would come hunting, we would clean up the place and perform religious services.
FATHER GREGORY

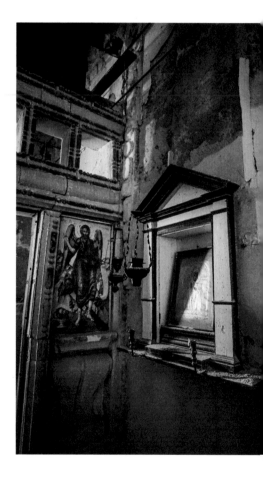

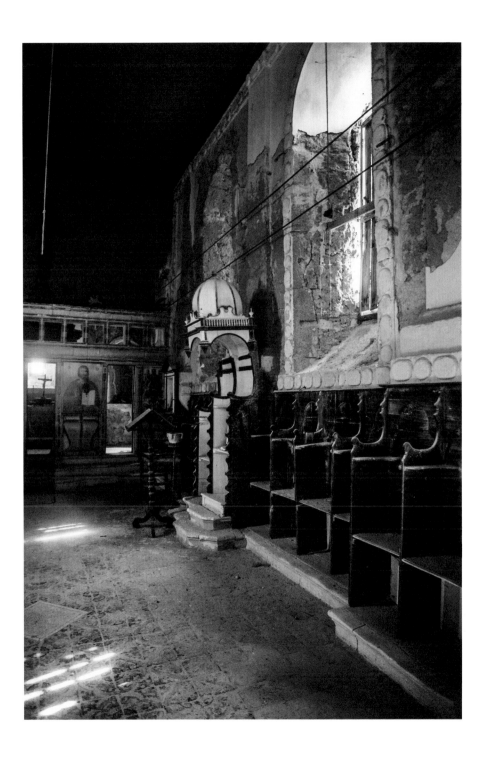

70 Often enough, we would perform
services in the Tower church.
We had Easter services there.
I remember the lighthouse
keepers, the hunters, and the
shipowners, who would come in
their own helicopters. We would
have *Anastasi* (Resurrection
Service) there at Easter. Father
Gregory baptized my kid here;
I even have a video of it.
LABIS KALOFONOS

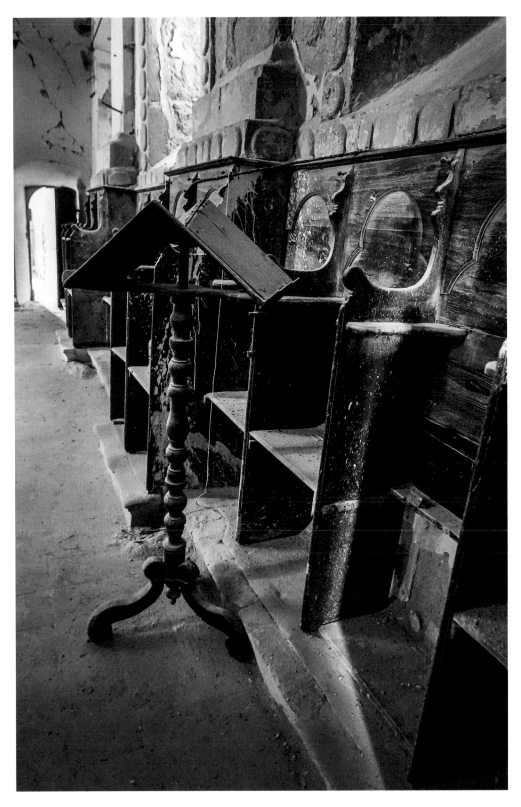

71 These photographs were taken
after the earthquake. If you see
cables, you know…. It's the cables
and the injections of concrete that
hold it up. They went and *injected*
concrete in the cracks. That's what
they did. And that was that. If it
falls down now, it's a lost cause.
These things don't get built again.
No one can build something like
that now. During the Occupation,
(WWII) they say that King Pavlos
went up to the Metropolitan of
Zakynthos and said that he had
visited the Monastery as a prince,
not a king. That's how awed he
was. He also said to "secure" the
Tower. The weather never ceases
to change here. The Tower has
always had problems but now
we're at an all-time low. If this
is abandoned …

FATHER GREGORY

(Note: this was the only time, during
our conversations, that his voice broke
and tears came to his eyes.)

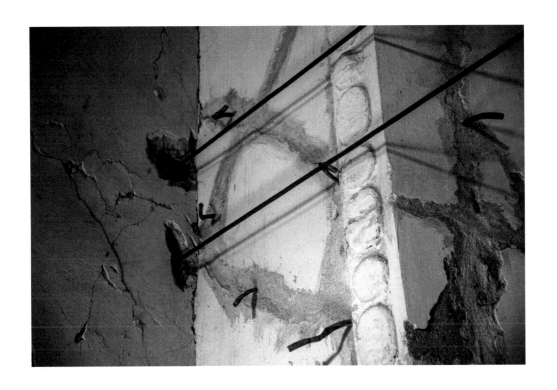

Eighteen wells on a remote, little island: Where do the island springs originate from?

Dr. Panagiotis (Takis) Karkanas

Stamfani, the largest of the two islets, is of great geological interest too. Foreign travelers in times past were astonished by its 18 wells and the presence of crystal clear, drinking water; some even claimed that there must be underground springs connecting the island to the opposite shores of the Peloponnese or even Zakynthos, despite the fact that the sea surrounding the islets goes to impressive depths.

The fact is, there is some water on the island—and there might have been more water in the past. The geology of Stamfani island is quite simple in terms of water movements and storage: the six-foot-thick formation that caps most of the island is composed of permeable coarse sandstones. They overlie impermeable marls and clays that make up the core of the island, with some gypsum masses in the form of intrusions (diapirs). So, water penetrates the sandstones, stops at the underlying clays and marls, and moves along the contact, following its geometry. It then emanates in small springs found at the topographic lows along the coast of the island.

In a study published in 1978 by Psarianos, Verginis, Verykiou, and Leivaditis (*Geography and Geology of the Strofades Islands*), the authors note that springs on Stamfani dry up during summertime and the needs of the islet are served by a well. This is reasonable, given the extent of the islet and the relatively small thickness of the permeable cap. The unknown element in this figure is the geometry of the contact of the permeable and the impermeable rocks. From the descriptions, it appears that there isn't any substantial relief at this contact and so a lot of water could be stored in local underground depressions probably along the contact with the gypsum diapirs.

The underground "reservoirs" on Stamfani could very well water the mixed forest of cedars (*Juniperus phoenicea*) and myrtle (*Myrtus communis*) covering one third of the islet's area.

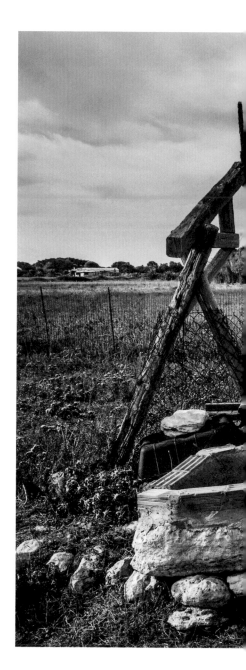

72 The island may be flat, but it's got 18 wells. There's one inside the Tower; it has drinking water. It's a big, very deep well, the one in the Tower. The water's freezing cold.
FATHER GREGORY

This is one of the many wells in the fields that have been destroyed. The island has grown wild and fierce lately. We've had droughts, not enough rain … the priest was pretty anxious about it all. The island may be flat but the texture of the ground is mountainous: rock and terra rossa.
LABIS KALOFONOS

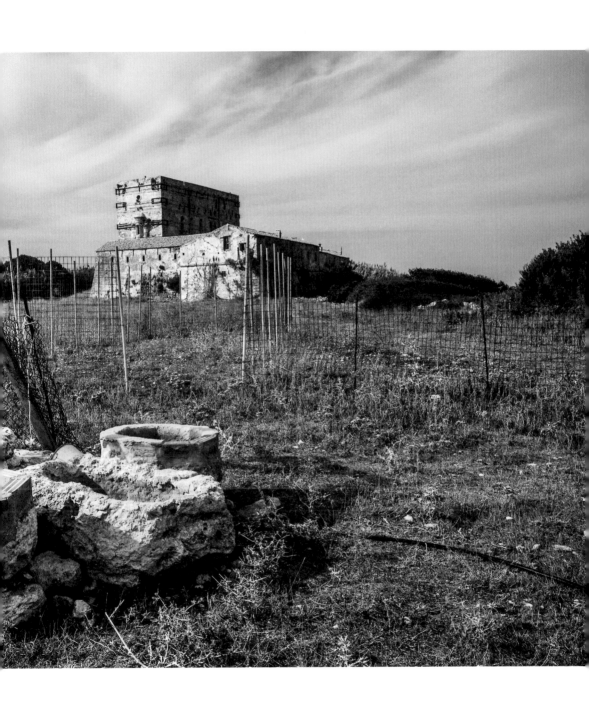

Endangered flora and fauna

Laurent Sourbes

The forest on Stamfani is one of the most important woodland areas in western Greece, not only in terms of the size of its trees, but also in terms of natural regeneration. All these particular environmental characteristics have turned Strofades into a designated Wildlife Refuge and protected area under the European Network of Natural Protected Areas NATURA 2000. Recently, the Special Protection Area (SPA) for Strofades and their maritime belt has been extended from 1.6 sq. kms. to 116 sq. kms. The main threats to the flora and fauna of the islets are blazes and illegal hunting. Poaching for turtle doves (*Streptopelia turtur*) during their spring migration has been a particularly serious problem.

OUTSIDE: PALM TREES

73 They only planted the palm trees recently. In the old days there was only one. They say that the Italians had camped on the island during the Occupation (WWII) and they'd shoot at the tree for target practice. They shot and they shot until they bore a hole in it. And that hole became bigger and bigger and when I came along there was this ferocious wind that blew and the tree bark broke right at the height of the hole. And the palm tree fell and it had been as tall as the Tower. It was by the laundry rooms, as you walk towards the old trailers, closer to the Tower.

LABIS KALOFONOS

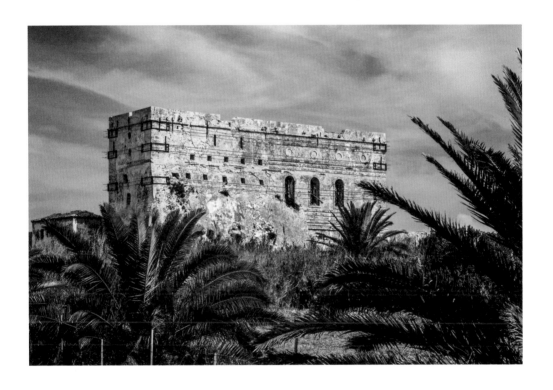

OUTSIDE:
GENERAL LAYOUT

74 This cross is close to the Saint's
cave. Where St. Dionysios lived
as an ascetic.
LABIS KALOFONOS

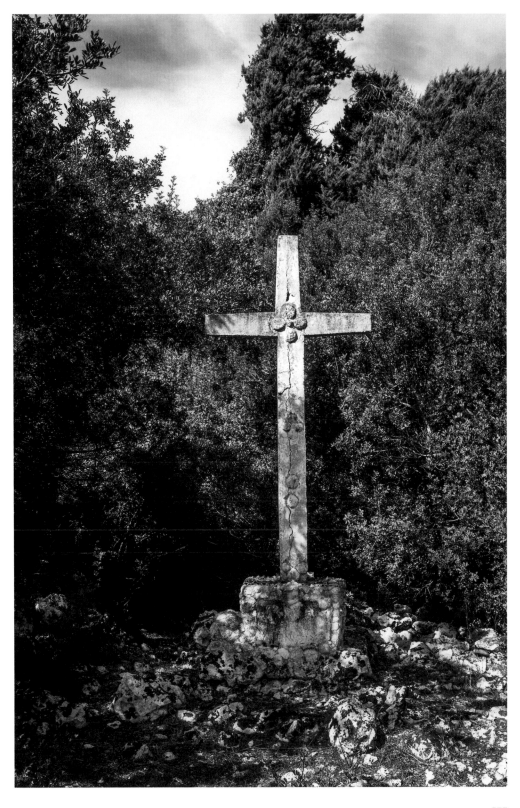

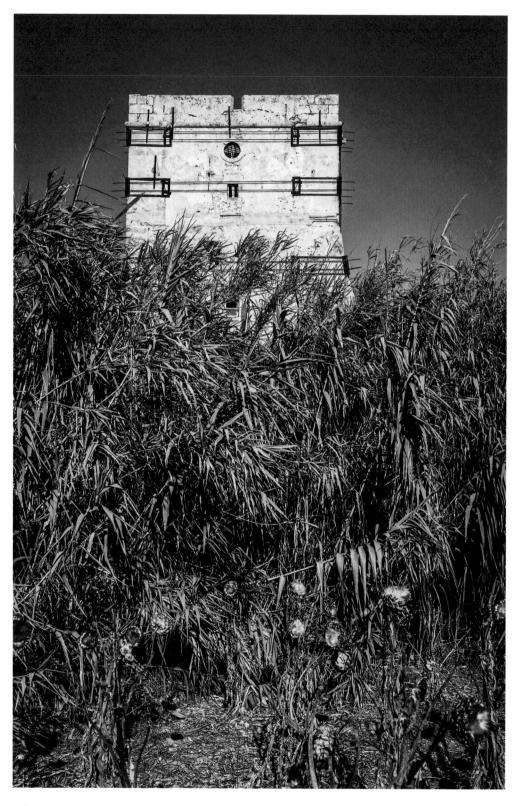

75 There are very strong winds blowing in Strofades. That's why nobody's done away with the reeds — they protect the buildings from the winds. You can see the Tower here, from the side where the reeds grow. And the artichokes. I used to grow artichokes diligently; I'd cut the flower heads and they'd sprout new side shoots. I loved eating artichokes. I cooked them myself, it was one of my loveliest dishes. I loved cooking for visitors too. First cook, then wash the dishes. "Don't do anything!" I'd tell my friends, who'd come along now and then. "You're *roufoutsafides*" (i.e. slapdash). They used to tell me I was a really good cook, that I made the best food. I never used tomato in my sauces, by the way.
FATHER GREGORY

76 No one touches the reeds on Strofades, they are windbreakers. To the left you can see the little arable plot of land and the artichokes. To the right, the garden.
LABIS KALOFONOS

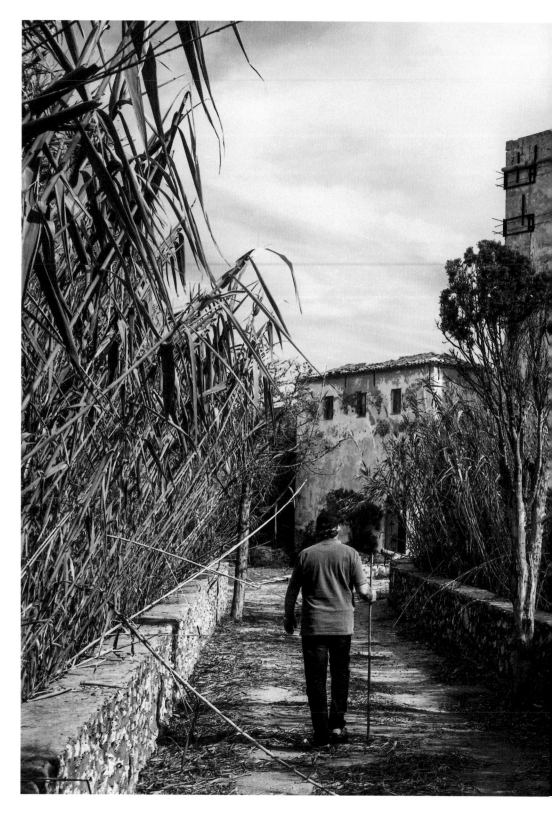

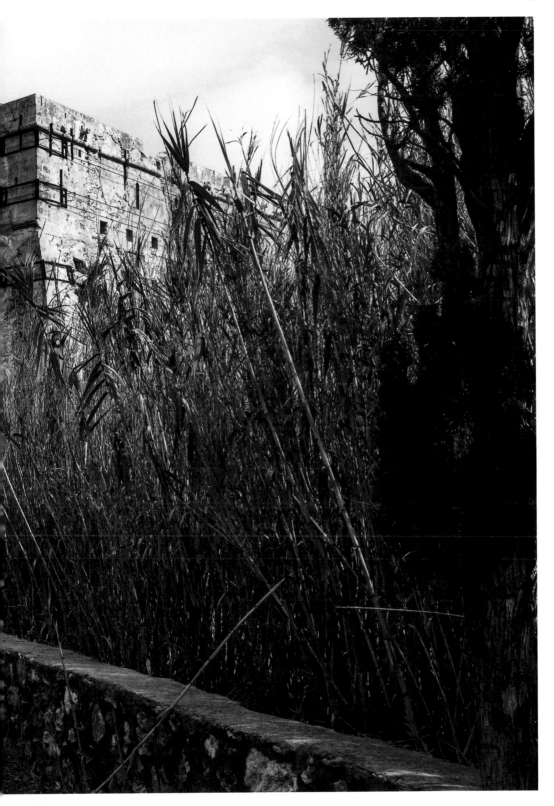

77 This is a blessed island. If you know
how to take what it gives you, you can
be self-sufficient here. That is, as long
as you know how to receive it with
respect, to be decent, to be a hard
worker. The island was blessed with
greenery and wheat. So you got your
flour and you made your bread. All
you needed was a fishing line—in
the old days, that is, now the sea is
ravaged—and you got yourself as
many fish as you wanted. You had
animals, you had milk, cheese, meat,
chicken, eggs…. God blessed this
place, I tell you. And game; you
could hunt.

LABIS KALOFONOS

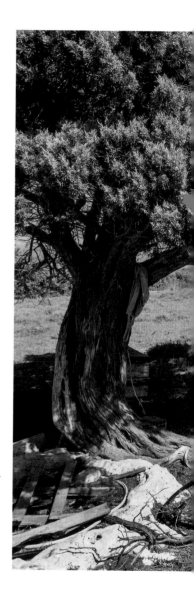

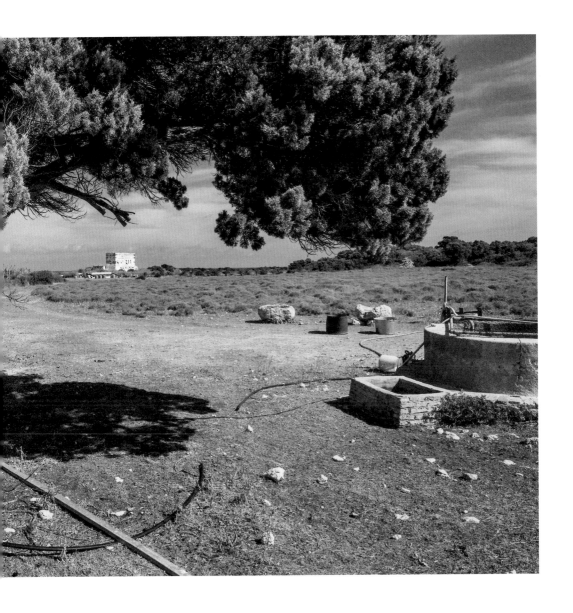

78 The forest didn't used to be as big as you see it now. When there were 40 monks on the island, they would cultivate almost the entirety of the land and when I used to go around it, in the old days, I would see dry stone walls, which means there were fields here, that the monks would sow seeds, that they had working animals, etc. They did have some forest, from which they got their wood, but it used to be much smaller.
LABIS KALOFONOS

79 Now the woods have grown thick and wild. Every little place on the Strofades has its own piece of history because so many men have lived here. I know the stories from Father Gregory, who had heard them from the previous monk, and so it goes. Every little place has its own name. Did you know there's a place here called Cedar Cape?
LABIS KALOFONOS

80 Father Gregory used to say
 "These are the Artinonisia (the
 islands of the shearwaters); they
 will always be the Artinonisia."
 We used to see thousands of
 Scopoli's shearwaters (Artines)
 lay their eggs in between the rocks.
 So, what I think Father Gregory
 meant, was that, even though
 there are fewer of them now, in
 the end, the shearwaters will
 conquer the island. The people
 will leave. As they have already …
 LABIS KALOFONOS

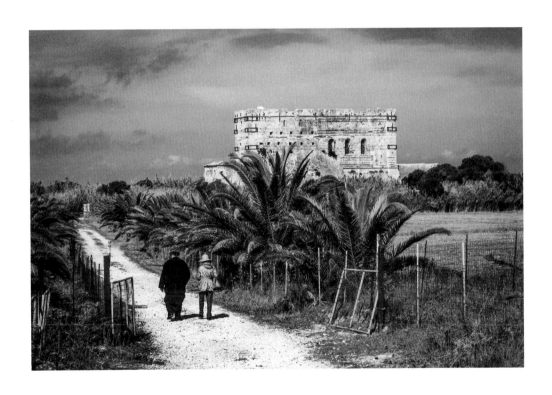

The isolated keepers of a historic lighthouse

Dionysis N. Mousmoutis

Time has left its mark on the lighthouse building too — another historic structure on Strofades. Its light shines at 92 feet above sea level, on top of a 36 feet square tower, on the largest of the two islets, Stamfani. There used to be five lighthouse keepers living in a house next to it. They lived alone, isolated for more than a month at a time, without a landline, without electricity, their only concern being to light up the beacon every night, so that passing ships would stay clear of the rocks. Monks and lighthouse keepers were the island's permanent inhabitants. The lighthouse was first lit up in 1829 and became a part of the Greek Lighthouse Network in 1864, when the Ionian islands were transferred to Greece. It was modified to operate on kerosene in 1887, and had a catadioptric lens, emanating a fixed white light punctuated by a flashing red glow once per minute, and having a range of 17 nautical miles. It first ran on petrol in 1925, emanating a light characteristic flashing white light every ten seconds, for ten seconds; its range was extended to 23 nautical miles. The lighthouse remained unlit during World War II. It was re-opened again in 1949, featuring a Dalén light (an automatic torch burning carbide gas), and in 1954, as part of the reorganization of the Lighthouse Network, it switched to supervised petrol burning until 1968, when new lighting equipment was added. The lighthouse was first powered by electricity in 1982 and new machinery replaced the old, petrol-based ones. It remained fully manned and supervised until 1985, when it was automated and fitted with modern machinery running on solar energy. It now emits two white flashes every 15 seconds, to a maximum range of 17 nautical miles.

THE LIGHTHOUSE

81 I started serving at the Strofades lighthouse when it was still 5-men strong. For the last 6–7 years of my service I was overseeing it alone: it had been automated. It was a classic lighthouse building, smallish, old. Inside the old keepers' house there were four rooms, but the actual lighthouse—mechanism and all—was about 100 feet to the side, standing separate from the building, and that's where we'd go to oversee its operation. I used to live in this house, in the front, with the other keepers. At other lighthouses, you often get the housing quarters and the mechanism all in one building. But not here. Our job was to ensure the maintenance of the lighthouse, to keep it clean, to make sure we trimmed off branches and things so that they wouldn't overgrow and cover the buildings, as they have now, to keep the machinery in good condition, and perform whatever task was necessary. The life of a lighthouse keeper is anything but easy. Now the work conditions have changed; it was much more difficult in my time. You were isolated, on some promontory far from the mainland, or on some desolate island where, to get provisions, you'd use tiny little boats under very difficult conditions. But I had so much fun! I'd have my wife with me, I had the company of a fine and good priest, Father Gregory, with whom we had some unforgettable moments. Most of the time it was us who went to see him at the Monastery, but Father Gregory would sometimes come to the lighthouse and eat with us.
DIMITRIS STITHOS

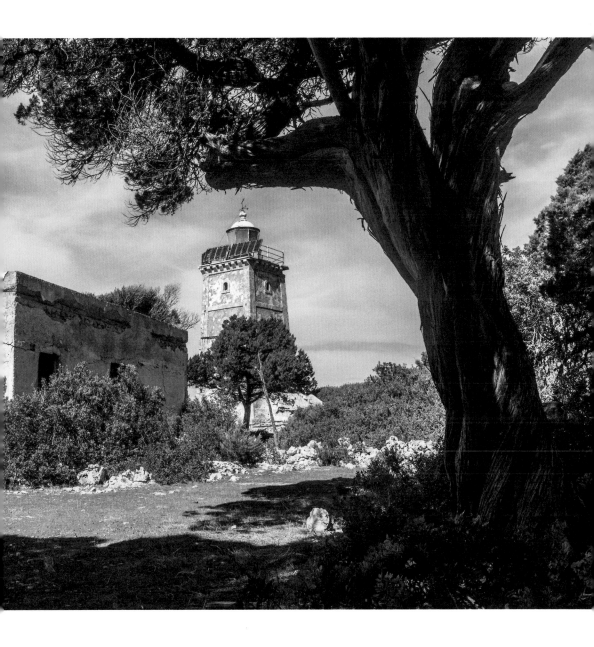

82 When the winds died down, you could reach the islets. When the weather was bad, no one could get anywhere close. There's this bench, they'd call it "the bench of despair." The lighthouse keepers used to call it thus, because they would look across the sea to Zakynthos, hoping the boat would come to bring replacement keepers. They'd take their luggage, their things, their packs, and wait. And because the boat was very often late, they'd call it "the bench of despair." They built a new one out of stone about 10 years ago. Before that, it was made of wood.
DIMITRIS STITHOS

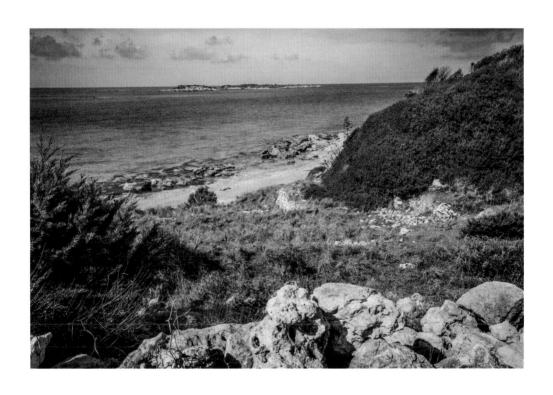

83 The Strofades Monastery is in a
sense intertwined with the light-
house. They are two links in a chain,
supporting each other. The Mona-
stery and the lighthouse on these
islets: they're something special.
There was harmony here, life, there
was love. Father Gregory and his
predecessors (and they were many),
they had great memories from the
lighthouse keepers. When Father
Gregory came to the lighthouse and
we'd finished eating, about half an
hour later, he would get up and go.
He rarely stayed longer than that.
But he did come, he did—for lunch
or for dinner sometimes. I've heard
many beautiful stories from my
older colleagues, even better than
my own stories!
DIMITRIS STITHOS

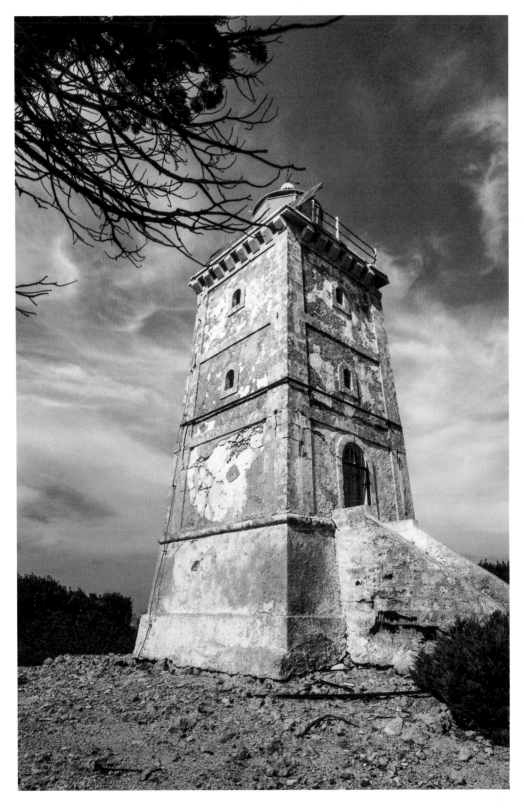

84 Oh, how I remember the very last
time I locked up the lighthouse!
How did this happen? It's simple,
really. The keeper follows orders
from the Navy's Lighthouse
Service, based in the port of
Piraeus. That's where my orders
used to come from — well, they
still come from there, today. So
I got this notice and it said that
the lighthouse was to be locked up
— un-manned, that is — because
it had become automatic; it didn't
need overseeing. And that I must
leave and transfer to the lighthouse
at Katakolo. Of course I remember
everything, how can't I? I got the
order and I was supposed to wait
for a little Navy boat to come and
pick me up. I'd swept the light-
house clean, I'd done it up, I left it
spick and span. I said goodbye to
Father Gregory the next day — it
was noon, I remember that — I'd
locked up the lighthouse and I left.
I sent the keys to the Service head-
quarters in Piraeus and I kept one,
as a souvenir. I see it every day, it
stands in a cupboard at home.
DIMITRIS STITHOS

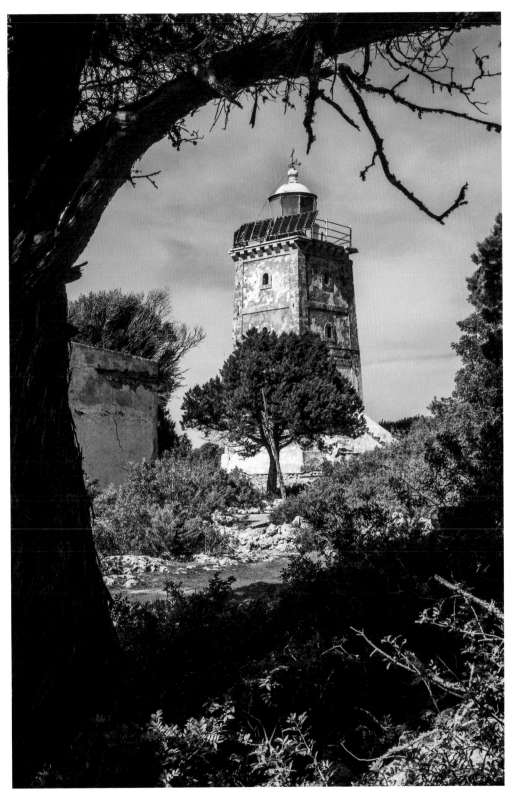

85 I was back to visit the lighthouse
 two years ago, with a friend.
 I saw it. It's dilapidated, in ruins,
 ravaged, it's got nothing to do
 with the place, when it used to
 be manned, when I was there.
 It's unrecognizable.
 DIMITRIS STITHOS

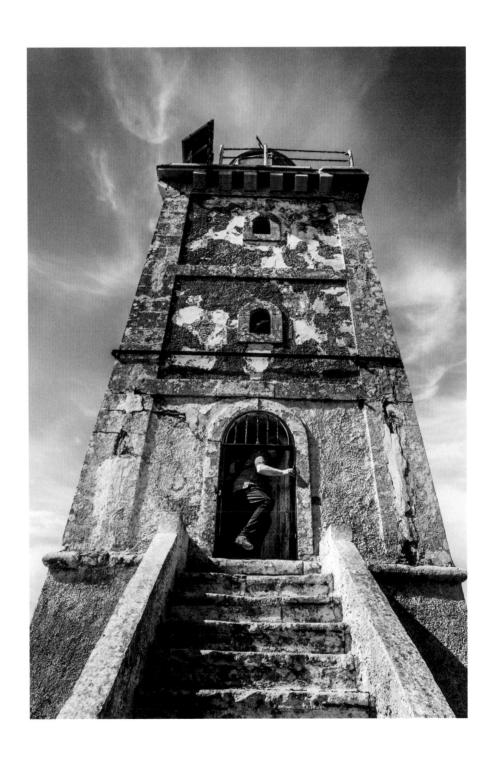

The Strofades Monastery:
Architecture and construction history

Stavros Mamaloukos

The Strofades Monastery is one of the few monastic complexes in the Ionian islands that still maintains some of its original, identifiable architectural qualities. Most others have been subject to various calamities, from historical catastrophes and earthquakes to unfortunate, modern attempts at renovation. The Monastery is one of the single most important monuments of late medieval and early modern history in the Ionian islands and the wider region. Yet, despite it having been the subject of scientific research projects, both the history and the architecture of this monumental complex have failed to be adequately studied.

The monastic complex's floor plan reveals a quadrilateral compound with maximum dimensions of 180 × 115 feet. It consists of four wings of buildings arranged around a narrow, elongated courtyard.

Most of the South Wing of the complex is occupied by the Tower, an impressive, massive, elongated, tall building, consisting of two separate lengthwise sections, clearly distinct from one another. The east end of the Tower is occupied by the *katholikon*—the main church of the complex; its western end houses the narthex, which also serves as a circulation area—a kind of a passage –on top of which there are two rows of small, low-height cells, and a granary.

A small compound of buildings occupies the western part of the complex, colloquially called The Western Buildings, which also incorporates the enclosure's western walls. The Western Buildings include the abbot's quarters (the *Hegoumeneion*), two small accommodation rooms over the gated entrance, and, on the ground floor, the bake house.

Along the entire length of the northern side of the complex stands a large, elongated, two-story building, the North Wing. The chapel of St. George—a small, elegant, domed church that was once the grave of St. Dionysios—is embedded within its ground floor. One also finds on the ground level two large storerooms and a horse-powered flour mill, whose impressive apparatus is still in good condition. On the upper floor of the North Wing runs a gallery (locally called *potzos*) providing access to a number of different, sequential spaces: to the west of the dome of the chapel of St. George one finds the kitchen and the refectory;

Views of the monastic complex looking south-west

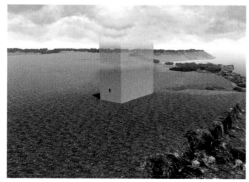

15TH CENTURY

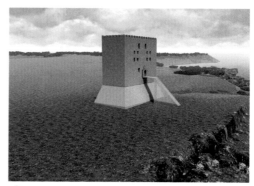

16TH CENTURY

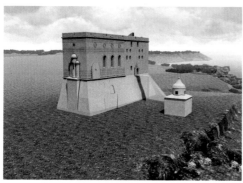

EARLY 17TH CENTURY

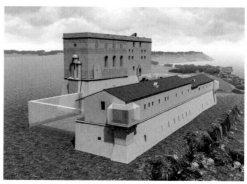

LATE 17TH CENTURY

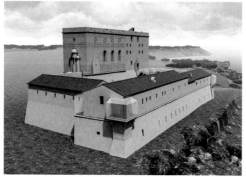

18TH CENTURY

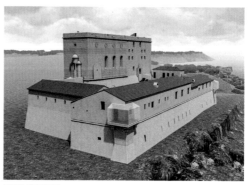

19TH CENTURY

and to the east of the dome, the guesthouse, a calefactory (warming house), and a series of monastic cells.

The Eastern Wing, finally, houses a vaulted warehouse on the ground floor and a series of sixteen cells above it. Connecting the Eastern Wing with the Tower is the Southern Wall, fencing off the final part of the complex's enclosure.

As the Monastery complex at Strofades has not as yet been subjected to systematic archaeological research, investigating its construction history has to cross-reference an examination of the monastic buildings with available historical data, *in situ* inscriptions, and the study of their architecture.

Only a very few visible parts of the monastic complex can be traced back to the Monastery's pre-1500 period with relative certainty. Its Byzantine phase is, otherwise, mostly evinced by various indications (like codices and icons), local lore, and written sources—the oldest of which, experts maintain, go back to the end of the 13th century. These parts are what remain of a relatively large church, a single-naved basilica, integrated today into the Tower's lowest level. Dating this church is rather difficult, but it appears not to be older than the 14th or even 15th century. It is probably to this church that the Franciscan monk and geographer Cristoforo Buondelmonti was referring in 1420, when he wrote that the Monastery possessed a "tower with a church inside." And it is probably this structure, also, that the bishop of Saintes, Louis de Rochecouart, characterized as a "fortified church" in 1461. The destruction of the church by fire, whose traces are still visible today, may be associated with attested catastrophes during the 16th century: one possibility points at the 19th of June 1537, when "the Turkish armada … burnt down and decimated (the Strofades);" another, to the sacking of 1571 by Kılıç Ali Paşa (known also as Uluç Ali, or Occhiali), who laid waste to the Monastery and massacred the monks.

Attempts to repair these extensive damages are most likely associated with the erection of the western part of the Tower, whose ground floor incorporates the remains of the old church, and whose first story is now part of the *katholikon*. Both morphological and structural elements cautiously suggest that the Tower was built sometime in the second half of the 16th century. It is quite likely that the exact date of its construction is engraved in the now, unfortunately, worn and illegible inscription on the original doorframe of the Tower's entrance.

It is during the same time—late 16th to early 17th centuries— that one should place the construction of the chapel of St. George. It is not known whether, or how, the chapel was connected to the rest of the Monastery complex during the time of its construction. It is, however,

quite likely that it was originally built as a cemetery church, which would explain the interment of the body of St. Dionysios there, in 1622.

According to a ktetoric, or dedicatory, inscription, the Tower underwent a thorough renovation in 1609. Work included the demolition of the original eastern wall down to the level of the first story and the construction of the present eastern part of the Tower, which now includes the *katholikon* (i.e. the main church) of the Monastery.

According to archival sources, extensive works were also carried out at the Monastery around the middle of the 17th century, but their exact nature is unclear. Is it possible that the construction of the North Wing can be traced back to this time? It should be noted that any evidence developed so far from studying the architecture of the building suggests that the North Wing was constructed on two levels from the outset. Additional proof that the upper story of the North Wing existed before 1781 is provided by a 1771 inscription at the guesthouse's hall (*portego*).

The Eastern Wing seems to have been built in 1700—if that is, indeed, the date noted on the embedded inscription on the building's western facade, right above the entrance to the first story. During the 18th century several repairs to the Monastery buildings were conducted after the 1717 and 1731 raids, and in the wake of several earthquakes, most prominently that of 1771 (archival sources and an inscription attest to this). Extensive work was also carried out during the 19th century, resulting, more or less, in the Monastery's present-day appearance. Minor repairs and maintenance works were also carried out after WWII.

Today, Strofades and their historical Monastery, devastated by earthquakes and deserted, no longer on pilgrimage or trade routes, of no interest to merchants or warriors, lie forgotten in eerie wilderness, awaiting restoration. Such a restoration project—a study drafted by the Department of Architecture at the University of Patras and aimed at supporting and restoring this unique, monumental complex to its original beauty—was approved more than five years ago, but no funding has been accorded to it as of yet.

The aim of the project is to maintain, repair, and make functional alterations to the complex, so that it can be revived as a place of worship and monastic life, but also as a historical monument accessible to the public. To achieve this, the aforementioned project proposes maintaining and restoring the buildings of the complex and, where necessary, restoring and reconstructing specific architectural elements that might have been damaged or destroyed. It also foresees specific, limited interventions in the buildings' interior layout in order to meet modern operational needs.

SURVEY DRAWINGS

Plans of the monastic complex.
Survey drawings with an indication
of its building phases.

Levels 1–4

15th century

16th century

early 17th century

late 17th century

18th century

19th century

20th century

LEVEL 3

LEVEL 4

0 10 20 30M

Plans of the monastic complex.
Survey drawings with an indication
of its building phases.

Levels 5–7

15th century

16th century

early 17th century

late 17th century

18th century

19th century

20th century

Elevations of the monastic complex

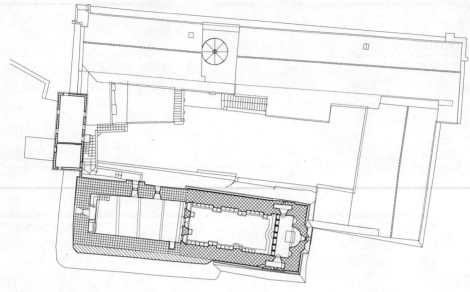

LEVEL 3

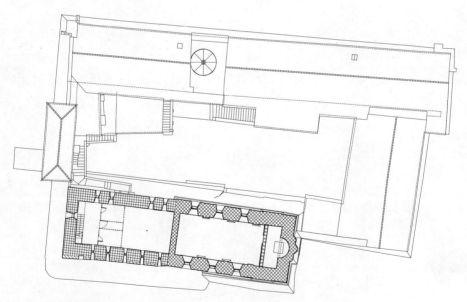

LEVEL 4

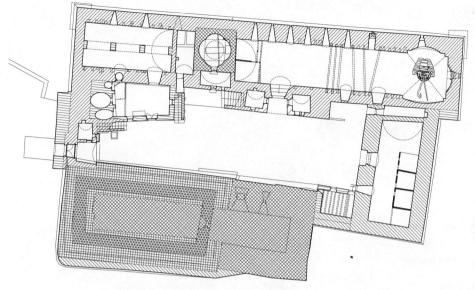

LEVEL 1

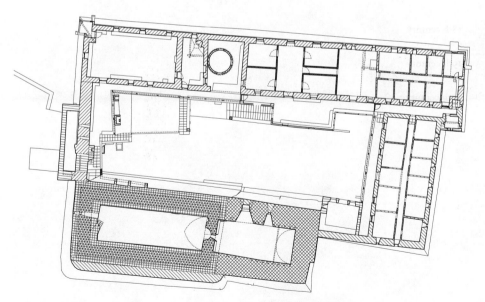

LEVEL 2

Plans of the monastic complex.
Survey drawings with an indication
of its building phases.

Levels 5–7

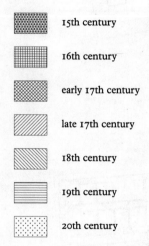

15th century

16th century

early 17th century

late 17th century

18th century

19th century

20th century

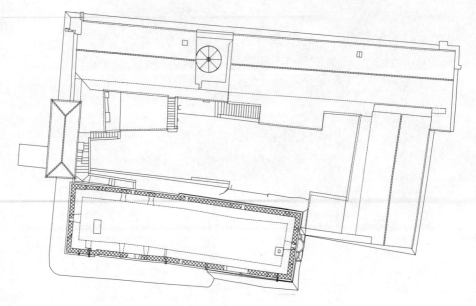

LEVEL 7

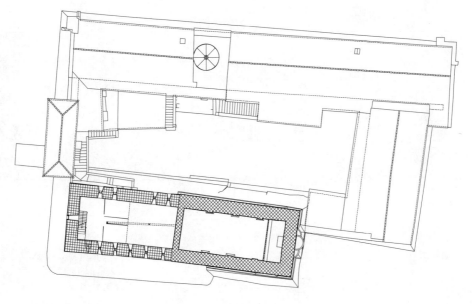

LEVEL 5

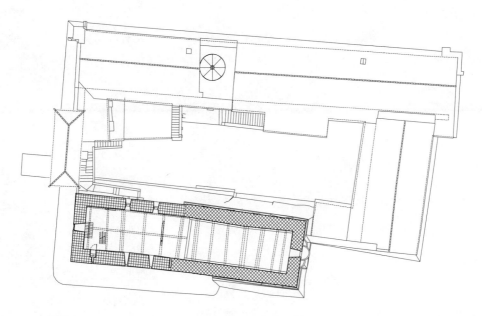

LEVEL 6

Elevations of the monastic complex

Sections of the monastic complex

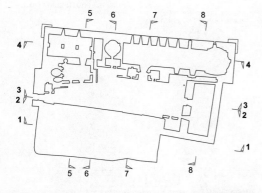

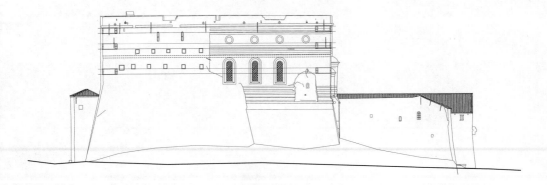

SOUTH ELEVATION

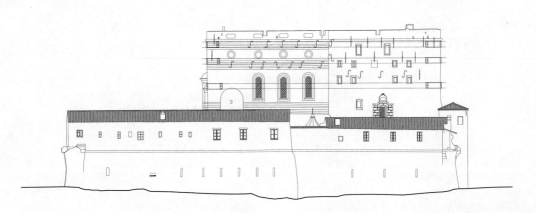

NORTH ELEVATION

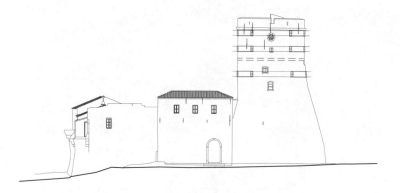

WEST ELEVATION

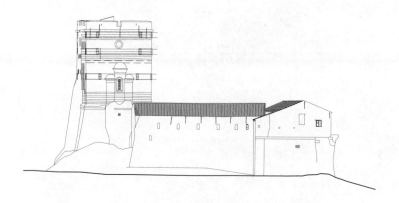

EAST ELEVATION

0 10 20 30m

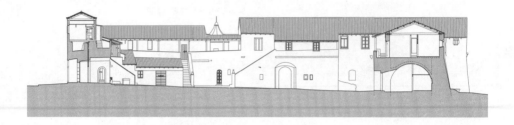

SECTION 3–3

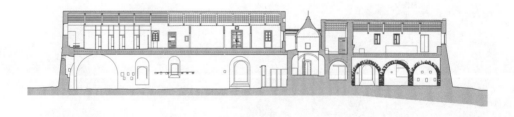

SECTION 4–4

0 10 20 30m

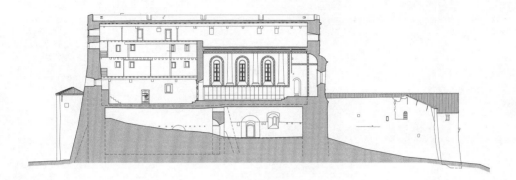

SECTION 1–1

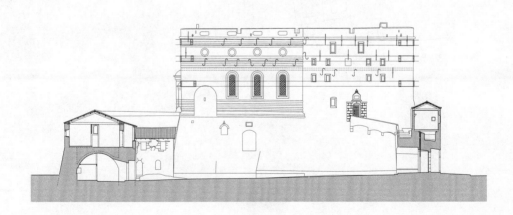

SECTION 2–2

Sections of the monastic complex

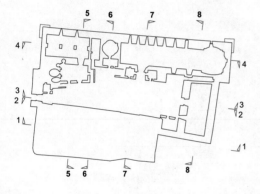

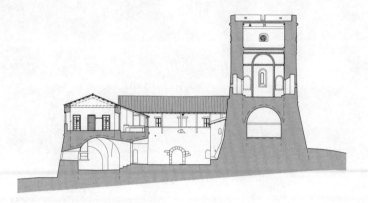

SECTION 7–7

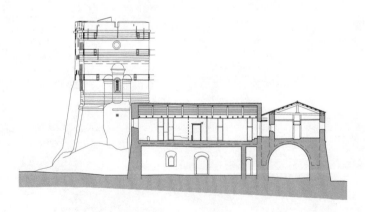

SECTION 8–8

0 10 20 30m

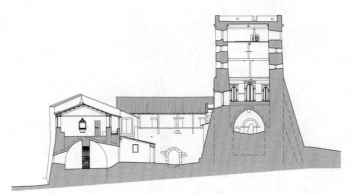

SECTION 5–5

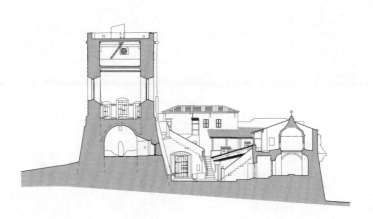

SECTION 6–6

RECONSTRUCTION
DRAWINGS

Elevation drawings of selected
construction phases

16TH CENTURY

EARLY 17TH CENTURY

18TH CENTURY

19TH CENTURY

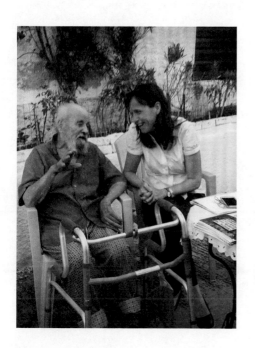

SOUTH ELEVATION WEST ELEVATION

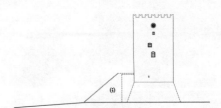

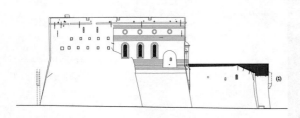

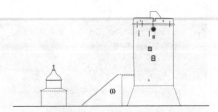

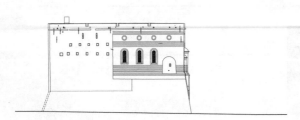

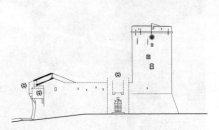

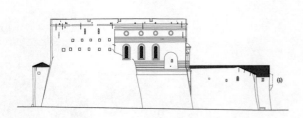

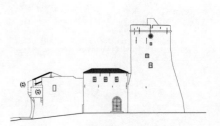

229

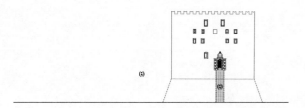

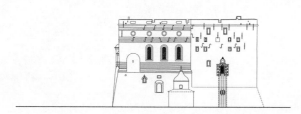

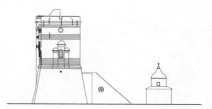

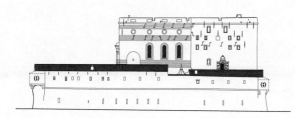

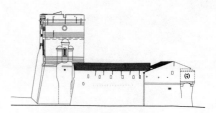

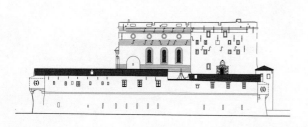

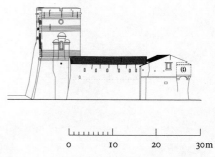

0 10 20 30m

Postscript. Father Gregory (7/7/2017)

What do you miss most about the Strofades?
—— I had everything. I was lacking nothing. Now I can't eat salt, because of my failing kidneys …

What was the most beautiful thing you used to do there?
—— The cheese I made.

And what gave you most pleasure?
—— That cheese. And my animals.

Weren't you ever afraid, all alone there?
—— No. Not once.

Do you think about the islets now?
—— Loads. It's a mutual kind of love.

Who stays there now?
—— No one, permanently.

So you were the last permanent resident.
—— ………

What made you stay there all these years, all alone?
—— I could avoid the whims of others. And others, mine.

You've been on Zakynthos for three years now. Would you like to go back to Strofades?
—— Dare I even think about something like that?…

Acknowledgements

The authors wish to warmly thank all those who have helped us in the preparation of this book. In addition to the Commentators and Contributors, who have devoted their knowledge and valuable time to this project, we wish to thank Akis Ioannides for his superb design; Sophia and George Marinos for their careful and thoughtful processing of the photos; Massimo Tonolli and his team at Trifolio for their wonderful printing of a complex book; Krystalli Glyniadakis for her eloquent translations; Benedetta Bessi for her translation of the nearly forgotten language of Buondelmonti; James Ottaway for his meticulous editing; Jenifer Neils for her evocative photograph taken in the Tower church; Liza Evert for her stunning aerial photographs of the Monastery; the Patras University team for their remarkable drawings and plans; the staff of The Holy Monastery of Strofades and St. Dionysios for their help; Sandra Marinopoulos for her advice in presenting the visual material; our publishers, Patakis Editions and Abbeville Press, for their support, guidance and patience; and finally thanks to Kostas Kefallinos, a.k.a. "the Moscovite" and Dionysios S. Tsilimigras, who brought us together with the late Father Gregory.

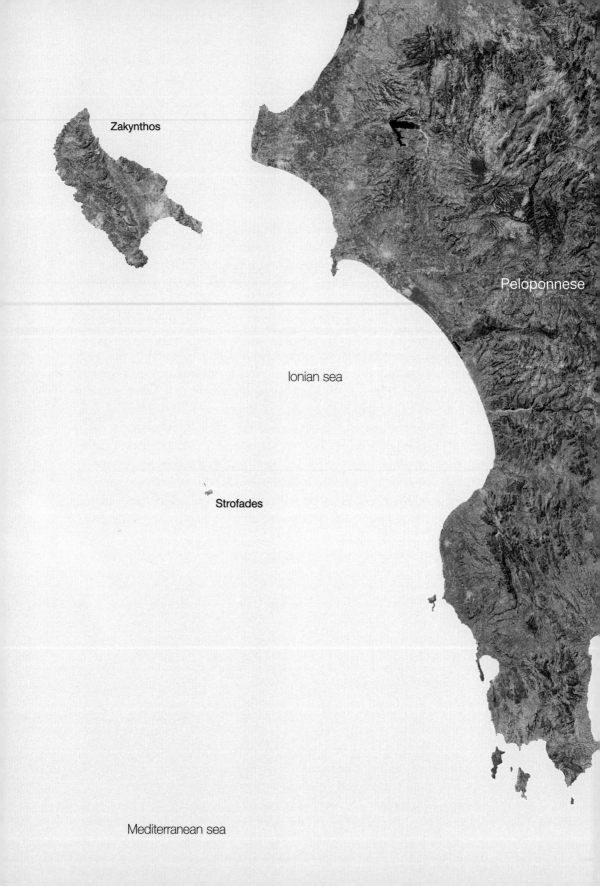

Zakynthos

Peloponnese

Ionian sea

Strofades

Mediterranean sea

List of references and sources

Anapliotis, Constantine (1963), "Sur la géologie des îles Strophades (îles Ioniennes, Grèce)," *Prakt. Akad. Athenon, vol. 38*, (Athens: Akademia Athenon), p. 519–528.

Chiotis, Panayiotis (1858), *Ιστορικά Απομνημονεύματα της νήσου Ζακύνθου*, Vol. II, (Corfu).

Hellenic Post (Edited Volume), *Ζάκυνθος, Μονή Στροφάδων*.

Moussouras, Dionysios Io. (2003), *Αι Μοναί Στροφάδων και Αγίου Γεωργίου των Κρημνών Ζακύνθου* (Athens: The Holy Monastery of Strofades and St. Dionysios).

Ponten, Josef (1914), *Griechischen Landschaften. Ein Versuch kunstlerischen Erdbeschreibens* (Stuttgart & Berlin: Deutsche Verlags-Anstalt), p. 221–239.

Psarianos, Verginis, Verykiou, Leivaditis (Eds.) (1978), "*Γεωγραφία και Γεωλογία των νήσων Στροφάδων*," *Annales Géologiques des Pays Helléniques*, (Athens: Faculty of Geology and Geoenvironment, University of Athens).

Theodoropoulou, Aikaterini Th. (2006), "*Η Μονή Στροφάδων: Αποτύπωση, Παθολογία, Προδιαγραφές Αποκατάστασης.*" BSc dissertation (Patras: School of Civil Engineering, University of Patras).

Waddington, George (1829), *The Present Condition and Prospects of The Greek, or Oriental, Church; with some Letters Written from the Convent of the Strophades* (London: John Murray).

Zois, Leonidas (2011), *Λεξικόν Ιστορικόν και Λαογραφικόν Ζακύνθου*, Vol. A, (Zakynthos: Museum of Solomos and Eminent People of Zakynthos).

Robert A. McCabe was born in Chicago in 1934. He started taking photographs in 1939 with a Kodak Baby Brownie given to him by his father, who published a tabloid newspaper in New York. His first visit to Greece was in 1954, equipped with a Rolleiflex with a 75 mm, f/3.5 lens and Plus-X film. In 1957, at the request of the *National Geographic Magazine*, he photographed widely in the Cyclades. He has continued to photograph in Greece in the ensuing years. His fifteen published books encompass Greece, Cuba, China, Antarctica, and Central Park. A new book *Mykonos: Portrait of a Vanished Era* has just been issued. Ongoing projects include: The Greeks and Their Seas; Santorini Before the Earthquake; Kasos 1965; A Portrait of Patmos; and The Waterways of France. He has made three visits to the Strofades, including a memorable visit with Father Gregory in 2005. He believes that photography is the perfect medium for what he calls poetic realism.

Katerina H. Lymperopoulou (born 1968, Athens) has been working as a journalist for the last 30 years—following the footsteps of her father, the Greek champion of pentathlon and long jump and one of the pioneers of sports journalism in Greece, Hary A. Lymperopoulos. She graduated from the National and Kapodistrian University of Athens (School of Philosophy) and has also completed a postgraduate degree at the same institution. She has worked for some of the largest newspapers in Greece ("Apogevmatini," "To Bima"). Her marriage to the Zakynthian Dionysios I. Tsilimigras has connected her closely with the Ionian islands and the Strofades. The couple have one child.

These aerial views of the Monastery
were taken by Liza Evert a few
months before the earthquake
of 1997. They were originally
taken for her remarkable book:
Fifty Small Islands of Greece.

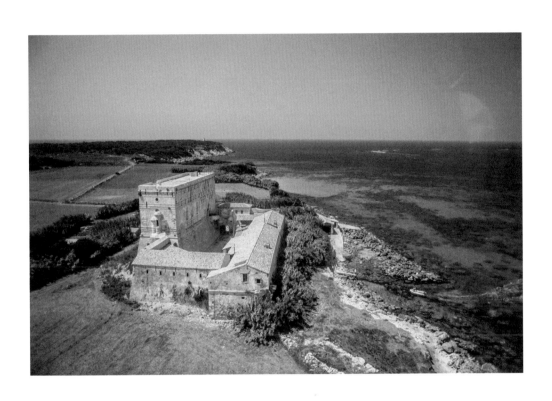

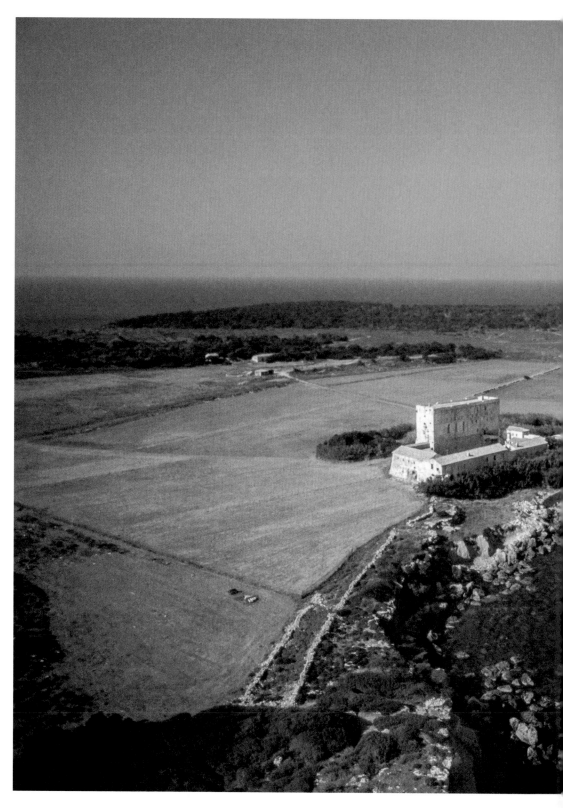

242

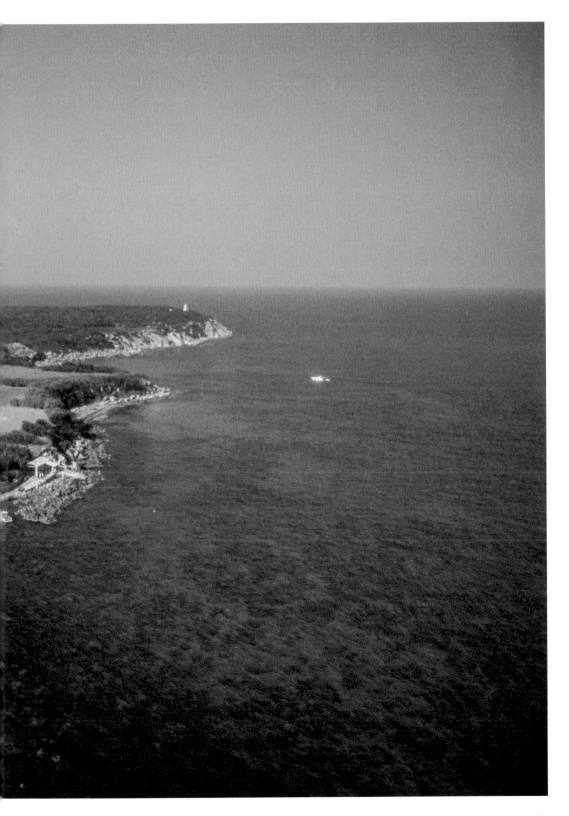

Design
Akis Ioannides

Scans
George & Sophie Marinos

Translation
Krystalli Glyniadakis

Printing and binding
Trifolio, Verona, Italy

Copyright © 2018 Robert A. McCabe
All rights reserved under international copyright
conventions. No part of this book may be reproduced
or utilized in any form or by any means, electronic or
mechanical, including photocopying, recording, or by
any information retrieval system, without permission
in writing from the publisher. Inquiries should be
addressed to Abbeville Press, 655 Third Avenue,
New York, NY 10017.

First Edition
1 2 3 4 5 6 7 8 10

ISBN 978-0-7892-1335-8

Library of Congress Cataloging-in-Publication
is available upon request.

For bulk and premium sales and for text adoption
procedures, write to Customer Service Manager,
Abbeville Press, 655 Third Avenue, New York,
NY 10017, or call 1-800-Artbook (U.S. only).

Visit Abbeville Press online at www.abbeville.com.
Visit Robert A. McCabe at www.mccabephotos.com

Image and text credits

All photos © Robert A. McCabe except when noted.

p.10
© Jenifer Neils

p. 26, 30, 32
© Katerina Lymperopoulou

p. 204
Reconstruction by Stavros Mamaloukos, 3D visualization by Thanos Yfantis
© Stavros Mamaloukos

p. 208–230
Based on drawings of a Research Program commissioned by the Holy Metropolis
of Zakynthos and Strofades and held by the Department of Architecture, University
of Patras, © Stavros Mamaloukos

p. 228–230
Reconstruction by Stavros Mamaloukos, © Stavros Mamaloukos

p. 241–243
© Liza Evert

Text copyrights © by contributor
Christina Merkouri; Stavros Mamaloukos; Chryssostomos, Metropolitan Bishop of
Dodona; Dr. Stamatis Chondrongiannis; Dionysios Moussouras; Dimitris Arvanitakis;
Dionysios Mousmoutis; Panagiotis Karkanas; Dionysios Zivas; Laurent Sourbes;
Katerina Lymperopoulou; Robert McCabe

Caption Copyrights ©
International Photography Publishers LLC–Katerina Lymperopoulou

Copyright © for the translation of Buondelmonti's text
Benedetta Bessi